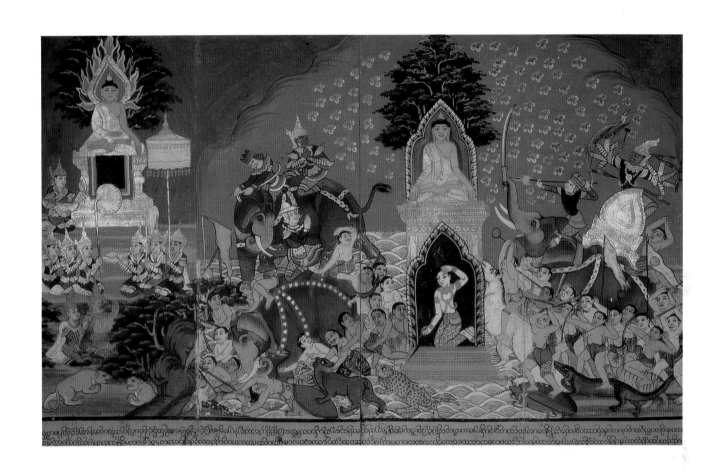

BURMA'S REVOLUTION OF THE SPIRIT

The Struggle for Democratic Freedom and Dignity

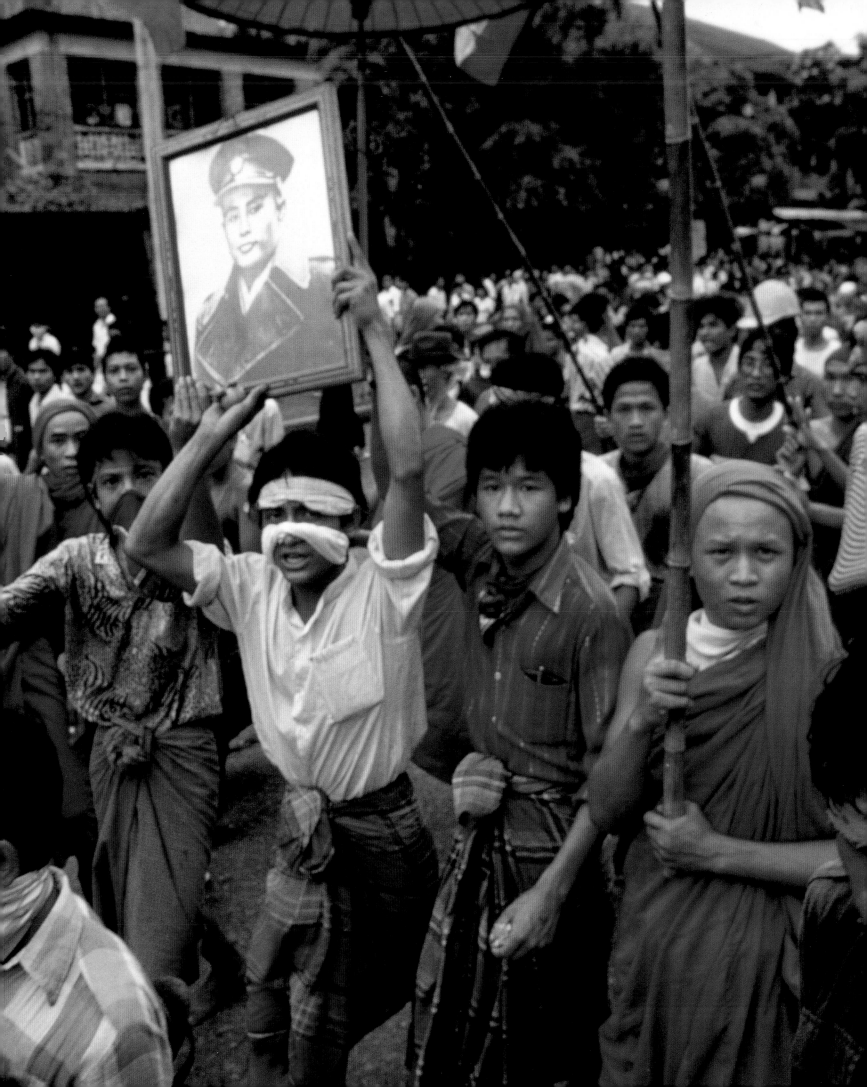

BURMA'S REVOLUTION OF THE SPIRIT

The Struggle for Democratic Freedom and Dignity

by Alan Clements and Leslie Kean

Foreword by His Holiness the Dalai Lama

Preface by Dr. Sein Win, Prime Minister of Burma in Exile

With commentaries by Nobel Peace Laureates Oscar Arias, Adolfo Perez Esquivel, Aung San Suu Kyi, Mairead Maguire, Rigoberta Menchu Tum, Archbishop Desmond Tutu, and Betty Williams

Essay by Nobel Peace Laureate Aung San Suu Kyi

APERTURE

Previous spread: The Ananda Temple in Burma's ancient capital, Pagan.

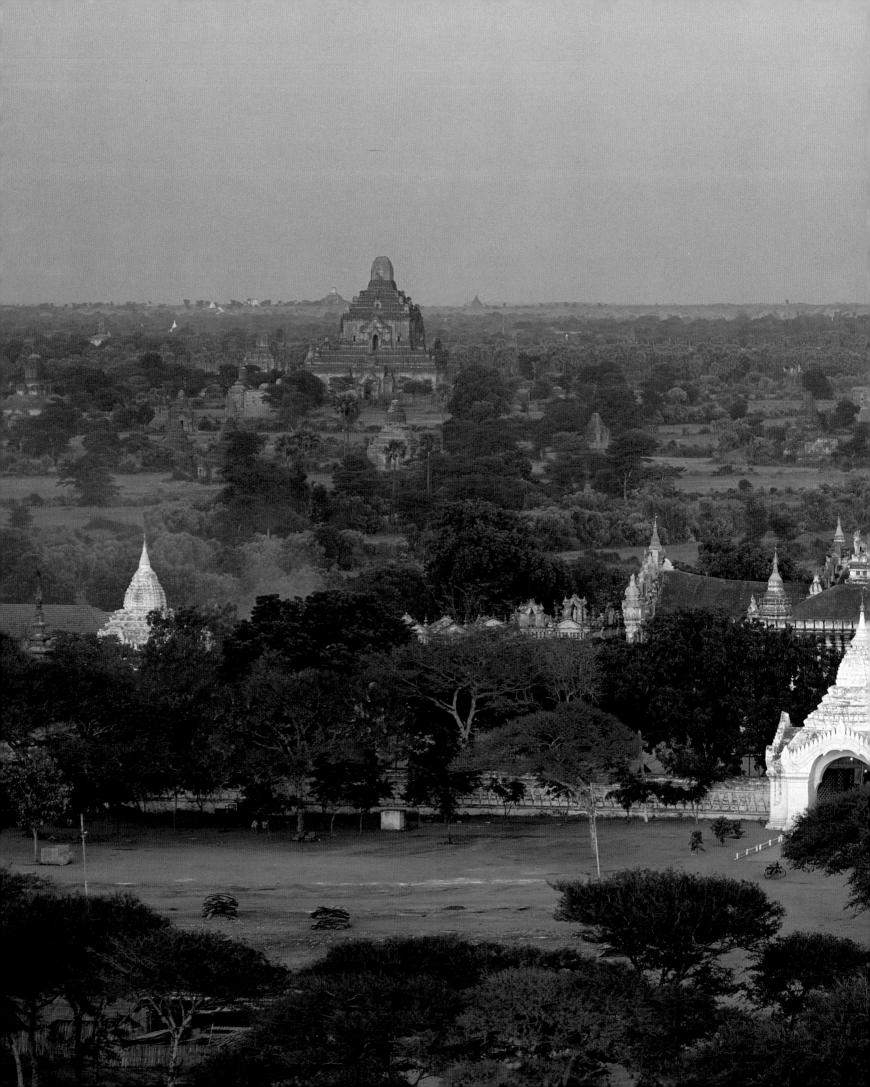

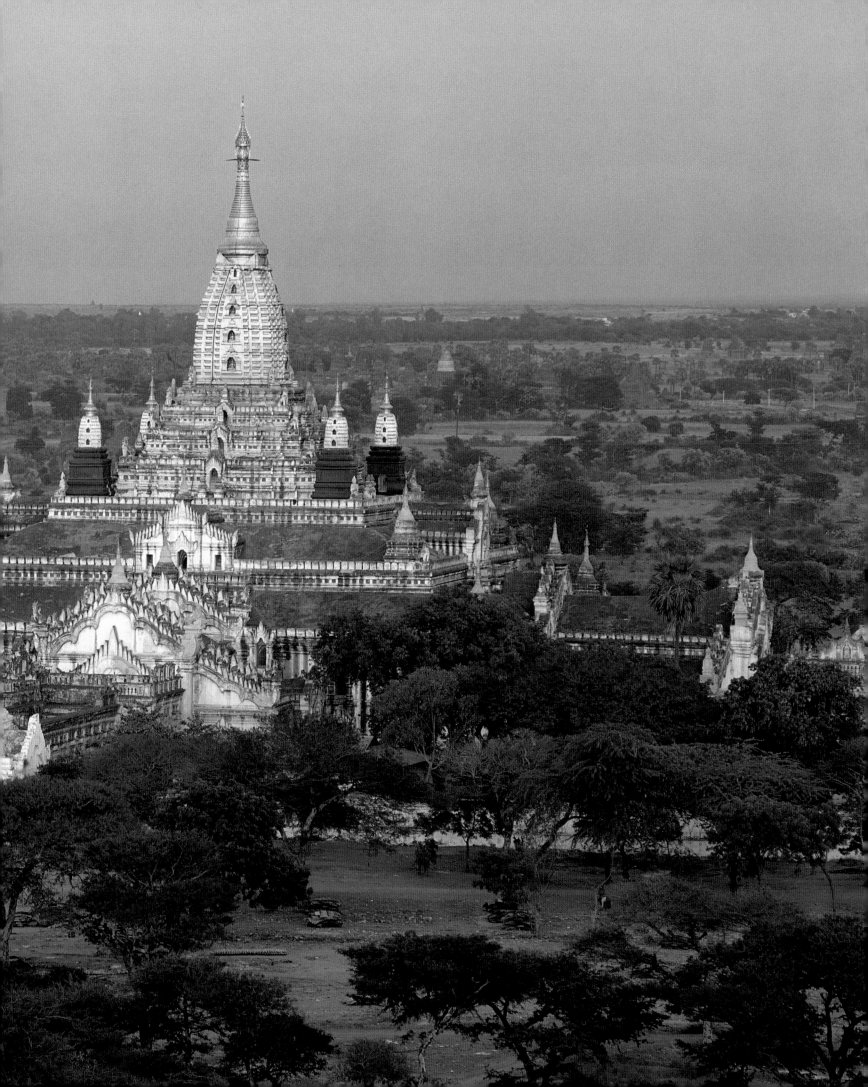

FOREWORD

In the final decade of the twentieth century, the world is becoming smaller and its nations increasingly inter-dependent. It has never been easier to travel to far-off places or to communicate across great distances. Yet the people of Burma, like my own people in neighboring Tibet, suffer under an oppressive regime beyond the reach of international relief.

What has happened in Burma is an example of a country being led in completely the wrong direction. The authorities' deliberate isolation of their country has achieved nothing constructive. Instead, this once prosperous nation is now impoverished. A happy, peaceful, and cultivated people have exchanged freedom and contentment for longing and fear. Where the Buddhist monastic community once gave a lead through education and an example of the religious life, the army now calls the tune. Nationalism is imposed by force, while opposition and minorities are harshly suppressed.

The military regime has as little regard for the environment as for its population. Forests that once were properly managed by local inhabitants are being destroyed with foreign equipment. They are not being replenished, and the proceeds go to maintain the voracious military machine.

Although the purpose of a large military establishment is supposed to be defensive, Burma is living proof that the very existence of a powerful military force in a country risks destroying the happiness of its people. We know that dictatorship is a despicable and destructive form of government, and here again is evidence that the existence of a powerful military establishment facilitates it. As else-where, it has imposed a tremendously wasteful burden on society. Not only money, but also valuable energy and human intelligence have been squandered, while all that has really increased is fear.

What then are the prospects for change in Burma? The military regime has so far failed to respond significantly to outside pressure. Undoubtedly the best solution would be the establishment of democracy, but it is the regime's denial of this that has caused the present deadlock. For unarmed civilians faced with a ruthlessly trained and equipped army, violence is not a good option. Anyhow, violence is always unpredictable. Therefore, it is far better to avoid it if possible, since you can never be assured beforehand whether or not its outcome will be beneficial.

In practice, it is always much safer to employ nonviolence. This is an approach anyone can adopt. It requires deter-mination, for nonviolent protest by its nature depends on patience. The Burmese people's greatest asset is the inspiring leadership of Daw Aung San Suu Kyi. Recognizing the immense suffering that would result from further civil strife, by her own determined passive resistance she encourages the finding of a peaceful, nonviolent way for the forces of freedom, truth, and democracy to emerge from the current atmosphere of unjust repression.

As long as we live in this world we are bound to encounter problems. If, at such times, we lose hope and become discouraged, we diminish our ability to face difficulties. I feel sure that it is Aung San Suu Kyi's awareness, even in her isolation, that it is not just herself but all her people who are undergoing suffering that sustains her and increases her determination and capacity to overcome whatever troubles she faces.

Humanity's innate desire is for freedom, truth, and democracy. The nonviolent "people power" movements that have arisen in various parts of the world in recent years have indisputably shown that human beings can neither tolerate nor function properly under tyrannical conditions. In their demonstrations for democracy, the Burmese people, too, spoke from their hearts, asserting their natural desire for freedom.

As leader of the party which won the elections, Aung San Suu Kyi represents the people and their aspirations. The authorities who have denied the Burmese will for democracy and who keep her under house arrest seek to deny the right of the people. The power that Aung San Suu Kyi continues to hold over the imagination of her fellow citi-zens, as well as friends and supporters around the world, proves that the simple expression of the desire of the people is an immense force in the human mind and the shaping of history. I offer my prayers for the freedom and well-being of all the Burmese people, for Aung San Suu Kyi herself, and the members of her family.

Tenzin Gyatso
His Holiness the Fourteenth Dalai Lama of Tibet
Nobel Peace laureate, 1989

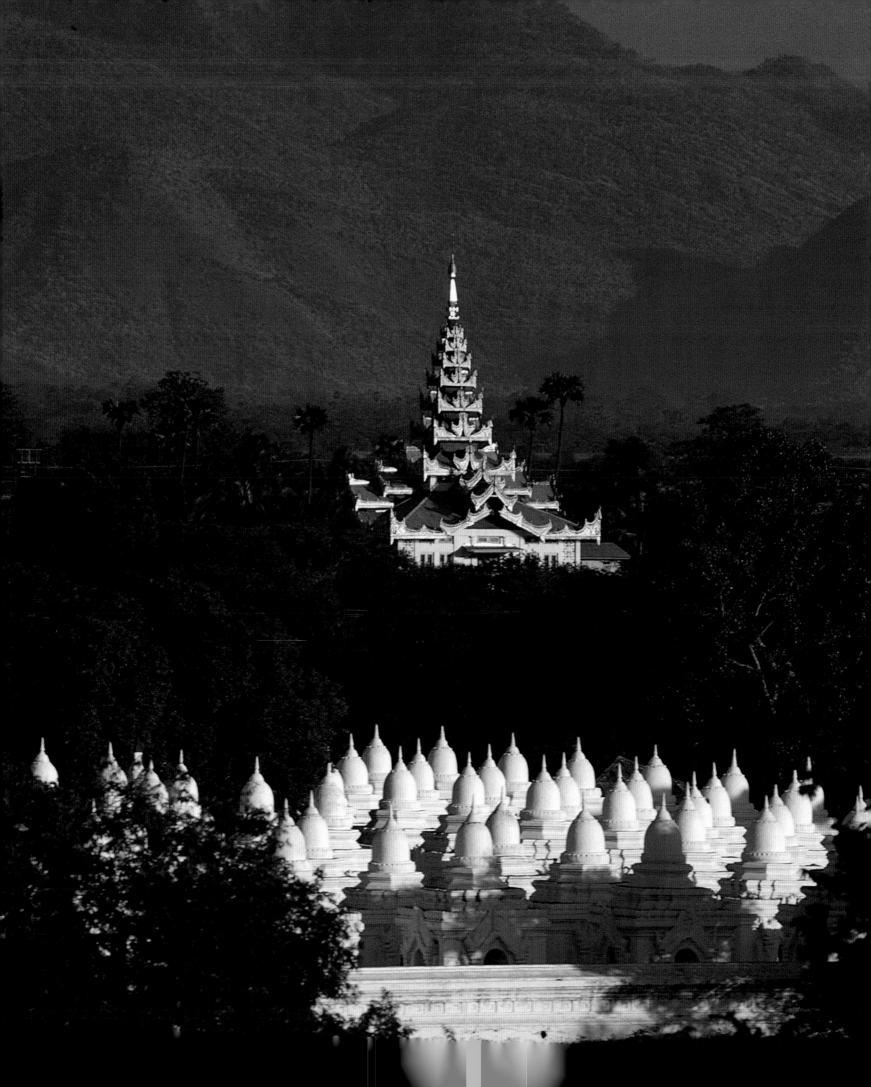

PREFACE

The nationwide uprising in 1988 against the totalitarian regime in Burma was a harbinger of what would follow in the global movement towards democracy. Oppressed people vented their long-pent-up fury and dictatorial systems fell by the wayside all over the world. Political changes swiftly followed, and the free world today basks in glory, celebrating the downfall of communism.

However, the struggle for justice and democracy continues in Burma. And many countries, particularly those which make economic gains out of the present situation, would like the world to forget about this struggle. They would rather see the people of Burma silenced, remaining nameless and faceless. It is in this light that I warmly welcome this book, *Burma's Revolution of the Spirit*. These photographs will bring the world's attention back to the suffering of our nation.

People of the world must see beyond the facade of military-sponsored mass rallies, new bridges and roads, and the newfound wealth of the military personnel and their friends. They must recognize the undercurrent, the extent of anger building up in the country. *Burma's Revolution of the Spirit* provides a true window into Burma. It helps the international community understand the undying spirit of revolution.

None of us were born revolutionaries. Circumstances have demanded that we stand up for our rights and we have done so. If that has made us revolutionaries, then we will proudly continue to be revolutionaries. As circumstances required in 1988, Nobel Peace Prize laureate Aung San Suu Kyi became Burma's most important revolutionary. While every person on the street knew that he or she wanted freedom, Aung San Suu Kyi more than filled the urgently needed leadership for the democracy movement. She gave direction to the masses, unifying the entire country through her tireless devotion. Everywhere she went she was greeted by thousands. Despite a ban by the military, people came out in throngs to dance on the streets and chant slogans. She gave courage to those who had been subjugated for years by a ruthless, oppressive regime.

This spirit lives on among the people today. It lies dormant in some, kept hidden because of the difficult circumstances facing most people in the country. And it soars high like a banner among those who openly fight for democracy. It is this spirit that the military junta most fears—a spirit that will eventually bring democracy and justice to Burma.

Dr. Sein Win, Prime Minister in Exile
National Coalition of the Union of Burma
January 1994

Dr. Sein Win is the exiled prime minister of the democratic opposition government in Burma. Shortly after the May 1990 general elections, the military regime mounted a suppressive campaign against the National League for Democracy and arrested nearly one hundred members of parliament. Conditions were not favorable inside Burma to form a provisional government. According to the mandate given by the remaining elected MPs, Dr. Sein Win went to the liberated areas on the border along with other people's representatives. The National Coalition Government of the Union of Burma (the provisional government) elected him to be prime minister.

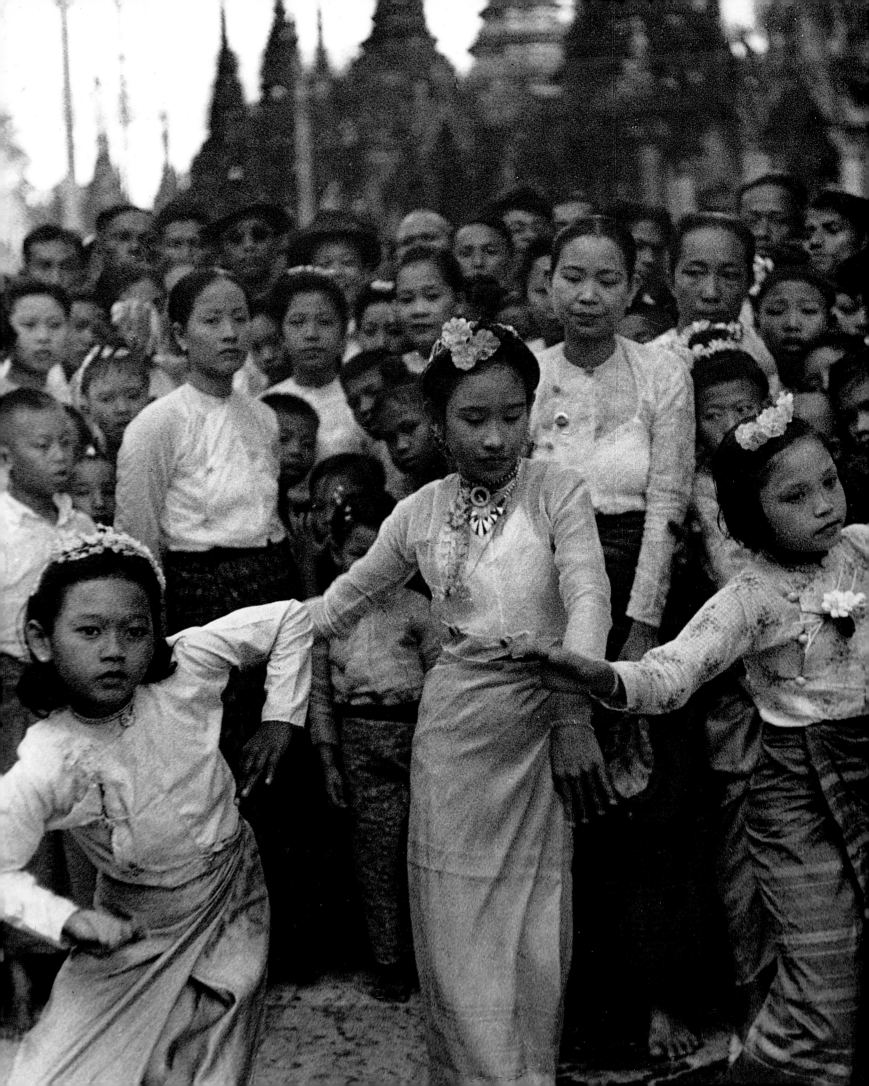

BURMA: THE GOLDEN LAND

Nestled beneath the far eastern end of the majestic Himalayan mountains lies Myanmar, a nation of forty-two million people, better known to the outside world by its colonial name, Burma. In the 1500s, European explorers chronicled a "golden land" where the ancient landscape shimmered with thousands of bejeweled and gilded Buddhist shrines against a backdrop of yellow rice fields. With an almost two-thousand-year-old culture, Burma is like an unexplored archaeological relic—still trapped in an ancient time.

Culturally, Burma remains unparalleled in its diversity. Quilted within the fabric of a predominantly Buddhist society are an astounding array of different indigenous races speaking over a hundred distinct languages and dialects. These diverse peoples have preserved their ancient cultures in a land so extraordinary it moved Rudyard Kipling to write, "Burma is the pearl of Asia...where the morning mists cloak the land in everything that is romantic and exotic and where the morning sun comes up like thunder."

This remote Southeast Asian nation remains one of the least documented countries in the world. The force behind Burma's recent isolation is a xenophobic military dictatorship that has intentionally sealed Burma from foreign scrutiny for over thirty years. During most of this time, journalists were expelled from the country and foreign visitors were restricted to a token twenty-four-hour stay. Photojournalists who managed to enter Burma between 1988 and 1992 took great risk with their lives to photograph events there, smuggling film out through any means possible while often facing grueling interrogation at the hands of the Burmese military.

✪

The nation we know as Burma was first formed during the golden age of Pagan in the eleventh century. King Anawrahta ascended to the throne in 1044, unifying Burma under his monarchy. His belief in Buddhism led him to begin building the temples and pagodas for which the city Pagan is renowned. Pagan became the first capital of a Burmese kingdom that included virtually all of modern Burma. The golden age of Pagan reached its peak during the reign of Anawrahta's successor, Kyanzitta (1084–1113), another devout Buddhist, under whom it acquired the name "City of Four Million Pagodas."

Although Burma was at times divided into independent states, a series of monarchs attempted to establish their absolute rule over the centuries, with varying degrees of success. Eventually, an expansionist British government took advantage of Burma's political instability. After three Anglo-Burmese wars over a period of sixty years, the British completed their colonization of the country in 1886, taking the last of a long line of Burmese kings into custody. Burma was immediately annexed as a province of British India, and the British began to

Opposite: During the Fire Festival (Thadingyut), Burmese girls perform a classical dance in front of the Shwedagon Pagoda.

The towers are built of fine stone; and then one of them has been covered with gold a good finger in thickness, so that the tower looks as if it were all of solid gold; and the other is covered with silver in like manner so that it seems to be of solid silver.... The King caused these towers to be created to commemorate his magnificence and for the good of his soul; and really they do form one of the finest sights in the world; so exquisitely finished are they, so splendid and costly. And when they are lighted up by the sun they shine most brilliantly and are visible from a vast distance.

The Travels of Marco Polo, 1298

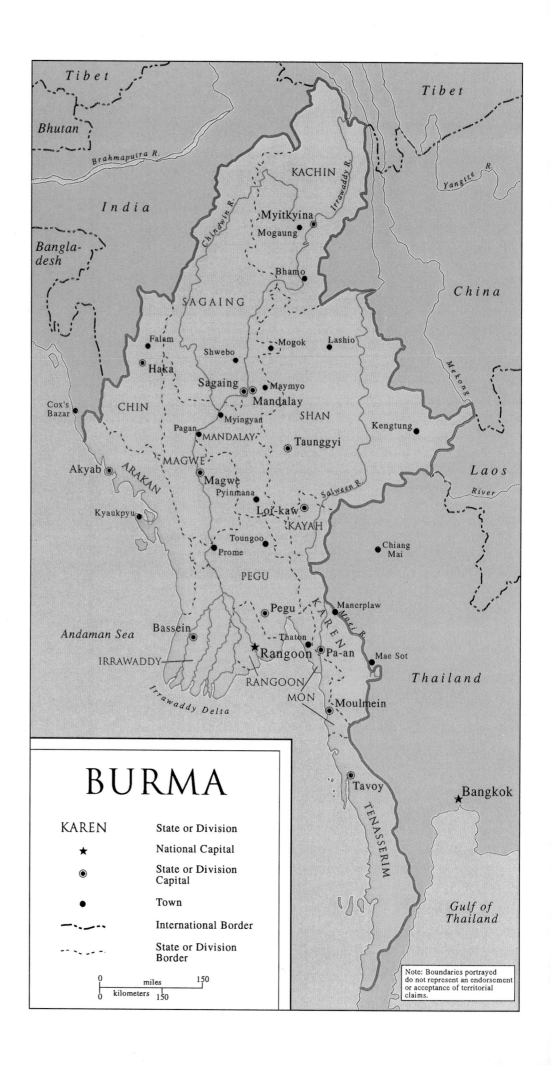

BURMA

KAREN State or Division

★ National Capital

◉ State or Division Capital

● Town

–·–·– International Border

– – – – State or Division Border

0 miles 150

0 kilometers 150

Note: Boundaries portrayed do not represent an endorsement or acceptance of territorial claims.

permeate the ancient Burmese culture with foreign elements. The British rulers trained the neighboring Indians to take over civil service jobs previously filled by Burmese. Burmese customs were often weakened by the imposition of British traditions. The British also encouraged both Chinese and Indians to migrate into Burmese cities in order to profit from new business opportunities. By the start of World War I, colonial architecture had become prominent throughout Rangoon, and foreign religious monuments and practices grew alongside traditional forms of Burmese Buddhism.

The British also further divided the numerous ethnic minorities by favoring some groups, such as the Karens, for positions in the military and in local rural administrations. During the 1920s, the first protests by Burma's intelligentsia and Buddhist monks were launched against British rule. By 1935, the Students Union at Rangoon University was at the forefront of what would evolve into an active and powerful movement for national independence. A young law student named Aung San, executive-committee member and magazine editor for the Students Union, came forth as the potential new leader of the national movement. In the years that followed, he successfully organized a series of student strikes at the university, gaining the support of the nation. To demonstrate his conviction that Burma was rightfully Burmese and not British, he and his closest associates defiantly called themselves *thakins*, or "masters," which was a title previously used only for addressing the British.

At the outbreak of World War II, Aung San seized the opportunity to bring about Burmese independence. He and twenty-nine others, known as the Thirty Comrades, left Burma to undergo military training in Japan. In 1941, they fought alongside the Japanese who invaded Burma. The Japanese promised Aung San that if the British were defeated, they would grant Burma her freedom. When it became clear that the Japanese would not follow through with their promise, Aung San quickly negotiated an agreement with the British to help them defeat the Japanese. Working together, the British, Indians, and Burma's Thirty Comrades successfully expelled the Japanese from Burma in May 1945, the same month that Hitler was defeated in Europe.

Hailed as the architect of Burma's newfound independence by the majority of the Burmese, Aung San was able to negotiate an agreement in January 1947 with the British prime minister, under which Burma would be granted total independence from Britain. An election was held to form an interim government, in which Aung San's party (the AFPFL or Anti-Facist People's Freedom League) won 248 of 255 assembly seats. Only thirty-two years old at the time, an eloquent and determined Aung San made a historic trip to London during this

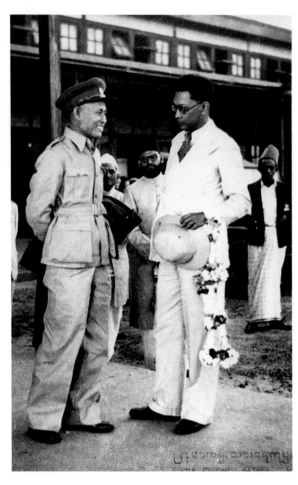

Above: Aung San (left) with his colleague M.A. Raschid at the Rangoon airport, moments before his departure to London to negotiate Burma's independence on January 4, 1947. He was assassinated six months later by a jealous political rival.

Opposite: In 1898, a group of young Burmese boys and girls posed prior to their ordination as novitiate Buddhist monks and nuns.

period of transition. Although a controversial figure to some ethnic minorities, he also met regularly with ethnic leaders throughout Burma in an effort to create reconciliation and unity for all Burmese.

As the new leader drafted a constitution with his party's ministers in July 1947, the course of Burmese history was dramatically and tragically altered. Aung San and his newly formed cabinet were assassinated when an opposition group with machine guns burst into the room. The man responsible, motivated by political rivalry, was immediately apprehended, tried, and executed one year later. A member of Aung San's cabinet, U Nu, was delegated to fill the position suddenly left vacant by Aung San's death. Although the nation was shaken by this monumental loss, Burma was finally granted independence on January 4, 1948, at 4:20 A.M.—a moment selected as the most auspicious by an astrologer.

For the next ten years, Burma's fledgling democratic government was continuously challenged by communist and ethnic groups who felt underrepresented in the 1948 constitution. Periods of intense civil war destabilized the nation. Although the constitution declared that minority states could be granted some level of independence in ten years, their long-awaited day of autonomy never arrived. As the economy floundered, U Nu was removed from office in 1958 by a caretaker government led by General Ne Win, one of Aung San's fellow *thakins*. Born Shu Maung, he had changed his name to Ne Win, meaning "the sun of glory." In order to "restore law and order" to Burma, Ne Win took control of the whole country, including the minority states, forcing them to remain under the jurisdiction of the central government. Although he allowed U Nu to be reelected Prime Minister in 1960, two years later he staged a coup and solidified his position as Burma's military dictator.

Ne Win's new Revolutionary Council suspended the constitution and instituted authoritarian military rule. The country was closed off from the outside world as the new despot promoted an isolationist ideology based on what he called the Burmese Way to Socialism. Superstitious, xenophobic, and ruthless, for the next three decades Ne Win set a thriving nation on a disastrous path of cultural, environmental, and economic ruin.

✪

Burma is the second-largest country in Southeast Asia, covering an area of 262,000 square miles—roughly the size of Texas in the United States. The country is situated along the Bay of Bengal and the Andaman Sea, forming a 2,000-mile coastline with some of the world's most spectacular and pristine beaches. Burma shares borders with Bangladesh and India to the northwest, Tibet to the northeast, and China, Laos, and Thailand to the east and southeast. The country

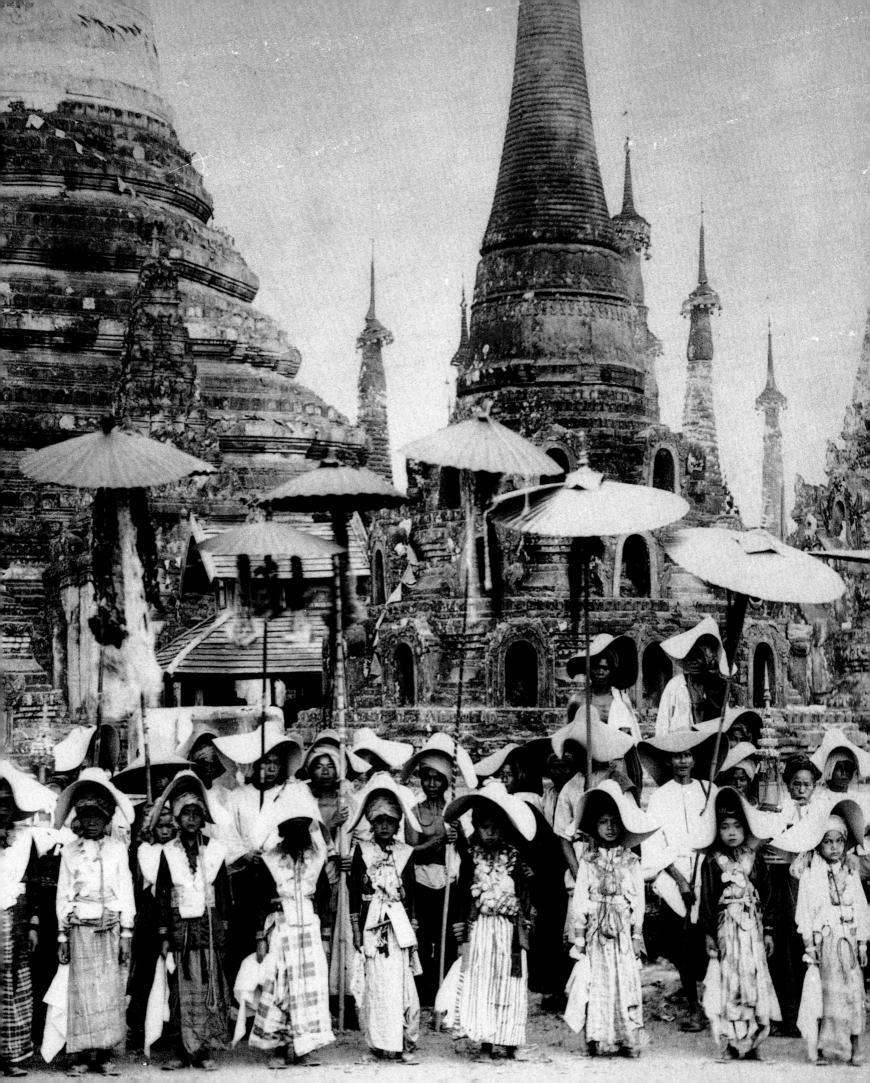

Opposite: One of the earliest photographs (1900) of
Rangoon's Shwedagon Pagoda—the most revered and
magnificent of all Burma's Buddhist monuments.

**It's not just that wonder of the world,
the Shwedagon; it is the atmosphere,
the varied scents, the ambience...and
the feeling of another world, a world
which one did not dare believe existed
any longer, save in the pages of books.**

Wilhelm Klein, *Burma*, 1982

is shaped like a kite with a long tail, enclosed by a large horseshoe
formation of magnificent mountain ranges and rugged forested hills.
There are numerous tall peaks among Burma's mountain ranges,
several of which are over 10,000 feet in height. Along Burma's northern
Himalayan border with Tibet, Southeast Asia's highest peak, Hkakabo
Razi, rises 19,314 feet.

Below these mountainous areas lie the vast interior plains of Burma.
These include a wide, dry expanse in the center of the country,
where classical Burmese civilization evolved, and also the lush delta
of the Irrawaddy River basin to the south, with its seemingly endless
fields of rice. In the southern delta lies the city of Rangoon, Burma's
capital of over two million. Mandalay, Moulmein, and Bassein are
Burma's next largest and most important cities, all with populations
in the hundreds of thousands; 80 percent of the Burmese people live
in rural areas.

Burma is an agriculturally based economy, depending heavily upon
its rivers as the sustaining source of its rice industry and inland
navigation. The major interior waterway is the Irrawaddy River,
which runs like a huge artery through the heart of Burma for 1,350
miles, from the northern hills to the Andaman Sea. It stretches more
than two miles wide in some places. The Chindwin River flows from
the northwest and joins the Irrawaddy in central Burma, and the
Salween comes down from the snow-covered mountains of Tibet
and flows through eastern Burma.

The spectacular lands of Burma have great ecological significance,
for they include some of Southeast Asia's last remaining tropical
rain forests. Burma provides habitat for a rich variety of wild animals,
such as elephants, tigers, leopards, buffalo, monkeys, the Himalayan
black bear, and even rhinoceros. An amazing variety of birds also
abound, as do venomous insects and reptiles.

Brought on by the monsoon winds ferociously sweeping across the
Indian Ocean, Burma's intense rainy season begins in May, peaks
between June and August, and finishes in October. Rainfall in an
average year varies from about two hundred inches along the coastlands
to between twenty-five and forty-five inches in the dry zone. The cool
season, which lasts from November through February, is the most
agreeable season in the Irrawaddy delta, although temperatures can
drop well below freezing in the higher elevations. March and April
are hot and dry, with temperatures in central Burma sometimes
reaching a stifling 113 degrees Fahrenheit.

Until recent times, Burma, a nation underpopulated relative to its
size, had always been considered one of the richest countries in

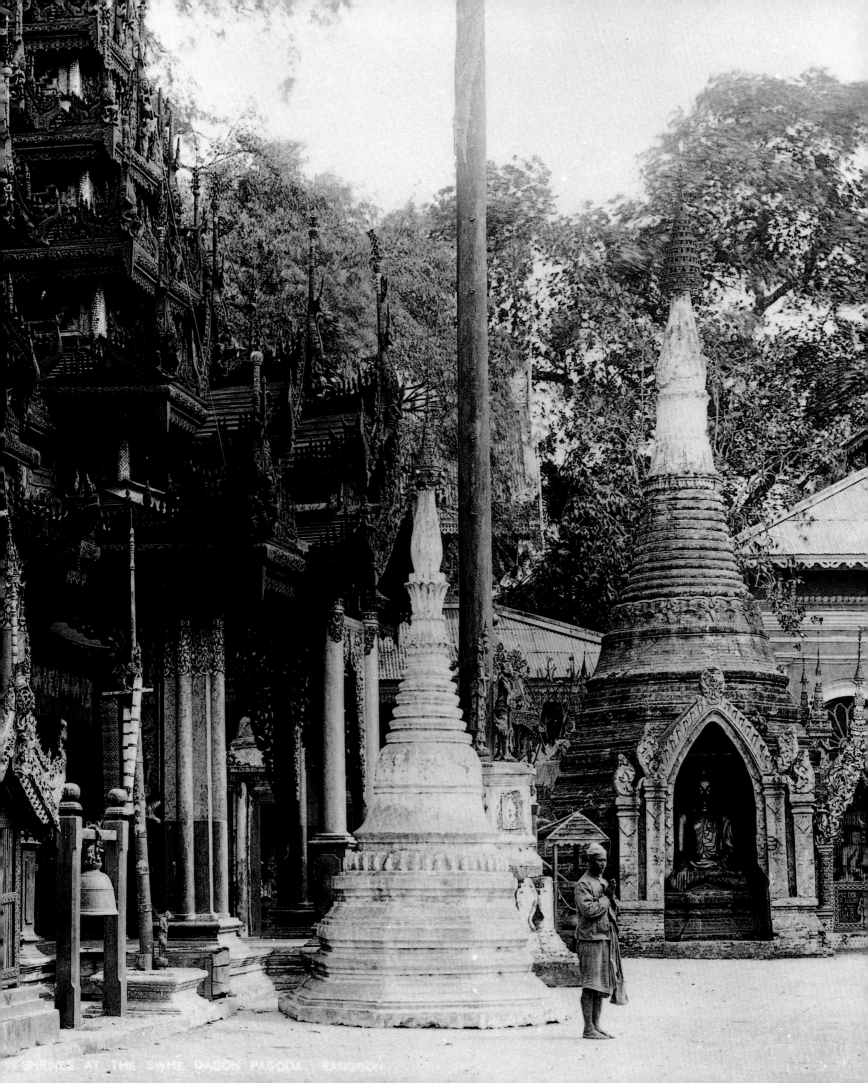

SHRINES AT THE SWHE DAGON PAGODA, RANGOON

Southeast Asia due to its abundant natural resources. Prior to World War II, while still under colonial rule, the country was known as "the Rice Bowl of Asia," since it was the world's largest exporter of rice. Burma's climate and soil are perfectly suited to rice cultivation, particularly along the Irrawaddy River and in its delta, which acts as a central source of irrigation for most of Burma's rice farming. Many other crops are cultivated throughout the country, including cotton, sesame, tea, jute, sugar cane, maize, and tobacco. The land also boasts a staggering array of minerals and gems, including tin, oil, gas, copper, zinc, gold, and emeralds. In addition, Burmese rubies are considered to be the finest in the world, and supplies of fine jade and freshwater pearls are abundant. Burma also has 75 percent of the world's teak-tree reserves. These natural blessings once made "the golden land" the envy of its neighbors.

Tragically, the people of Burma are no longer benefiting from the inherent natural riches of their country. Due to gross mismanagement and industrial nationalization by the military dictatorship, Burma has become one of the ten poorest nations of the world. In 1987 it was granted Least Developed Country status by the United Nations, putting it on a par with Ethiopia and Bangladesh.

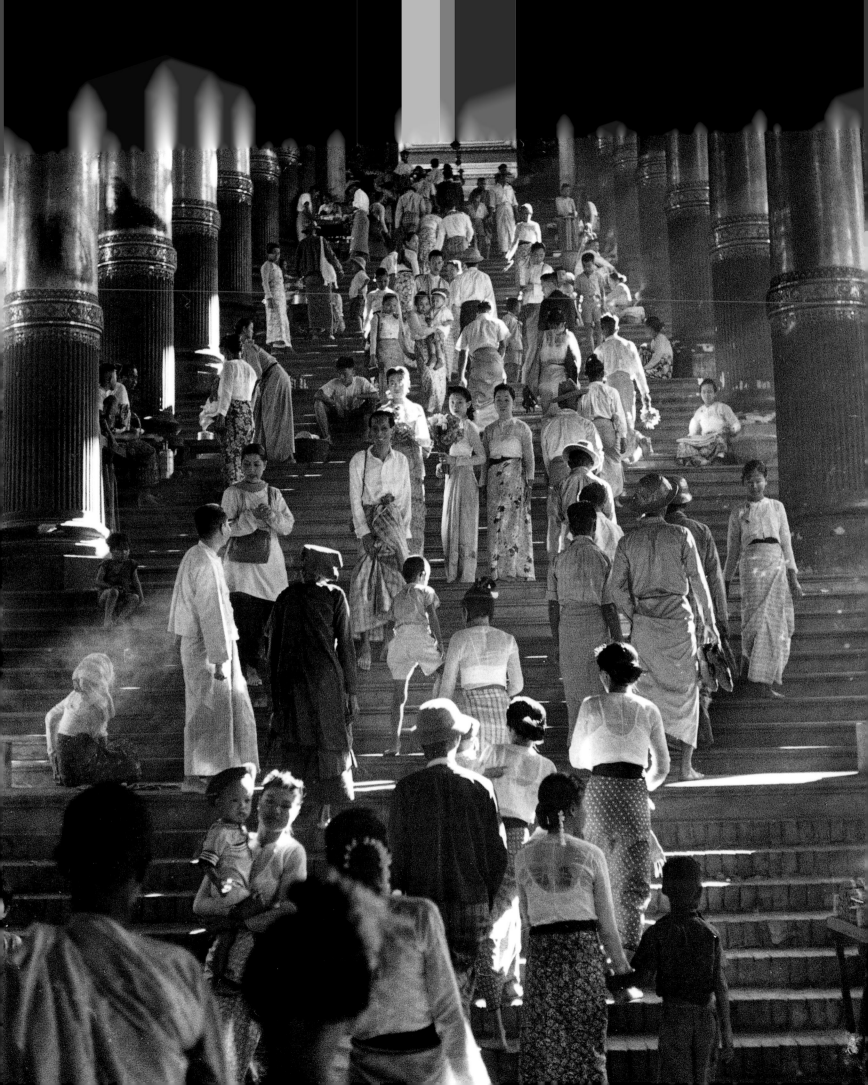

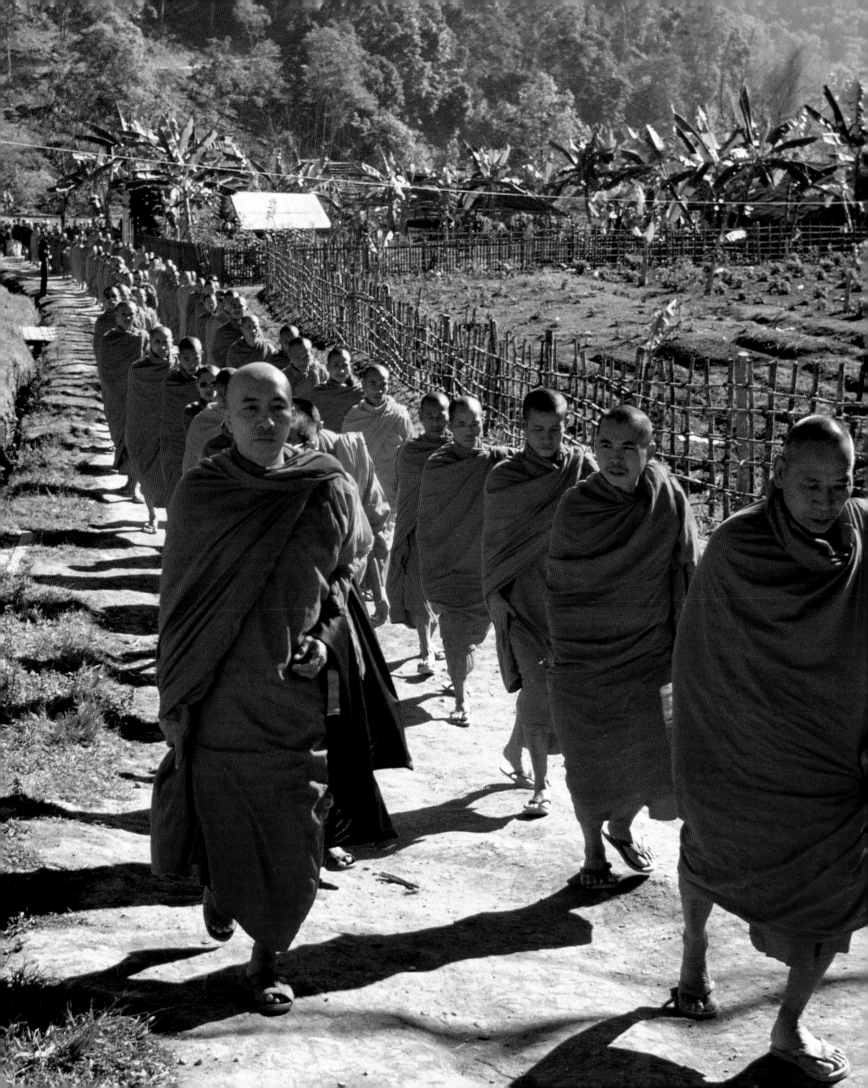

THE PEOPLES OF BURMA

Although Burma is still largely unknown to the Western world, it is considered by many to be one of the most enchanting, culturally rich, and spiritually sophisticated nations on earth. There are few countries in the world that contain such a diversity and complex mixture of peoples. At least sixty-seven separate indigenous groups live in Burma's forests, mountains, and plains, along with generations of Indians and Chinese. A British survey in the early part of this century made the amazing discovery that 242 separate languages and dialects were spoken.

Current estimates hold that approximately 68 percent (thirty million) of the Burmese are Burmans (Burmans are an ethnic group who speak Burmese, while the word Burmese refers to any inhabitant of Burma), while the wide array of ethnic groups make up the remaining 32 percent. Population numbers are inconsistent depending on which survey is consulted, and no reliable figures have been collected since 1932. (The 1942 census figures were destroyed during World War II.) The Burmans dwell largely in the central river valley, and their habits and customs are those most often thought of as being Burmese. The surrounding mountains and coasts contain seven distinct minority states, the majority of which are named for their principal inhabitants: Chin, Kachin, Karen, Kayah (or Karennis), Mon, Arakan, and Shan. The Shans (9 percent) and the Karens (7 percent) are the most numerous of the ethnic groups. Each of these and their many subgroups are descended from one of three major linguistic groups: the Mon-Khmers, the Tibeto-Burmans, and the Thai-Shans.

Throughout Burma's long and tumultuous history, there were times when conflicts gave rise to wars among the various races. Some of that legacy continues today. But predominantly, over the centuries in which ethnic relations and territories were constantly changing, the different races learned to adapt to each other and be mutually accommodating. These groups were not assimilated by the controlling central kingdoms and managed to preserve a tradition of autonomy. Out of respect for their past, the Karen and other indigenous groups have been struggling for recognition from the central government for over forty years.

A Sampling of Ethnic Diversity

The Mon: For centuries the Mons have taken pride in their high regard for aesthetics and traditional cultural values, establishing themselves as a race of great writers and poets. Culturally, the Mons and the Burmans are closely linked. Over the decades, the Mons have been largely assimilated into the mainstream of Burmese Buddhist culture, even though for periods they maintained their own state and retained their own distinct language. In the Shan State live one of the largest

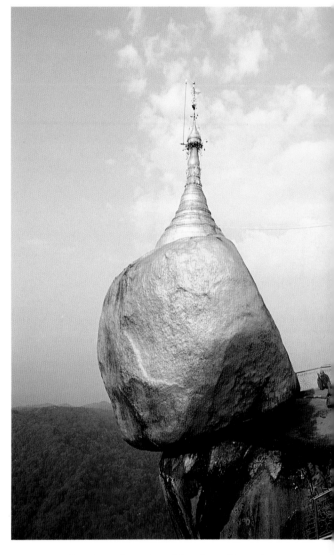

Above: The Kyaik-tiyo Pagoda in Mon State. Burma's renowned "Golden Rock" was constructed in the eleventh century. It sits perched precariously on top of a huge boulder at four thousand feet, and is said to keep its balance on the edge of a cliff due solely to a single hair of the Buddha preserved inside the shrine.

Opposite: A procession of Buddhist monks on their daily routine outside the monastery, preserving an unbroken ancient tradition of Burmese monasticism.

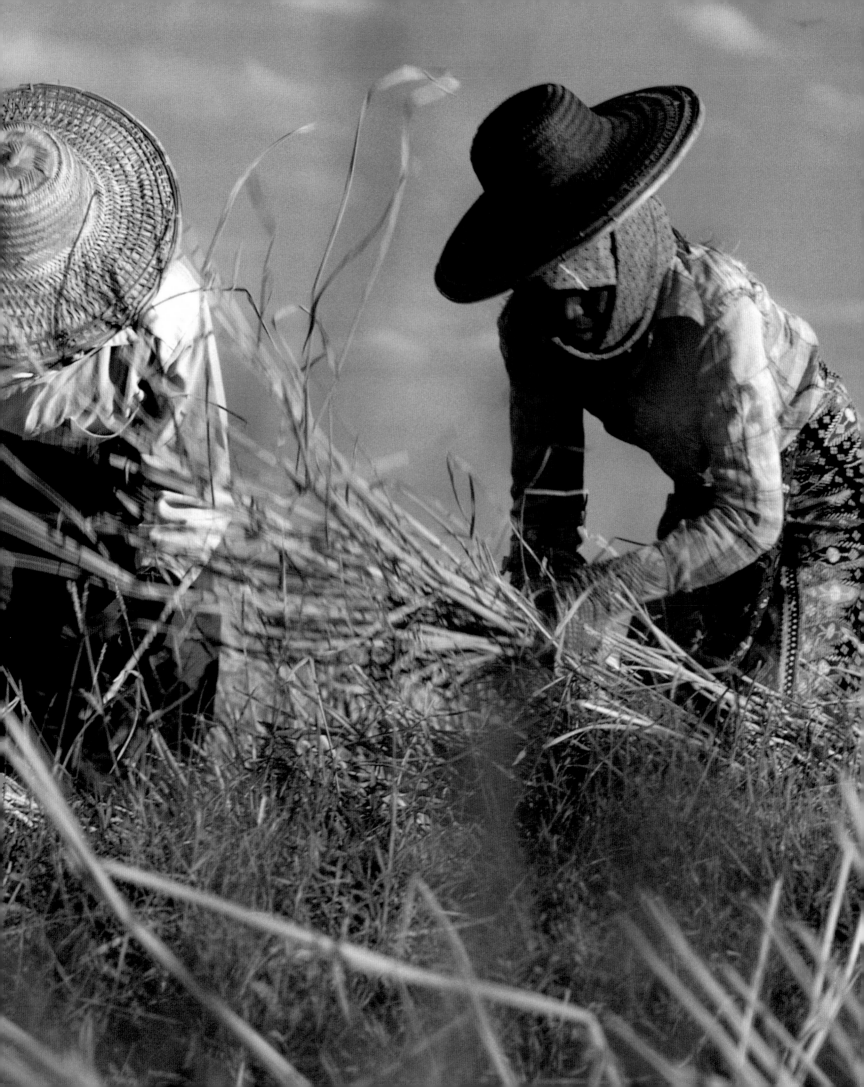

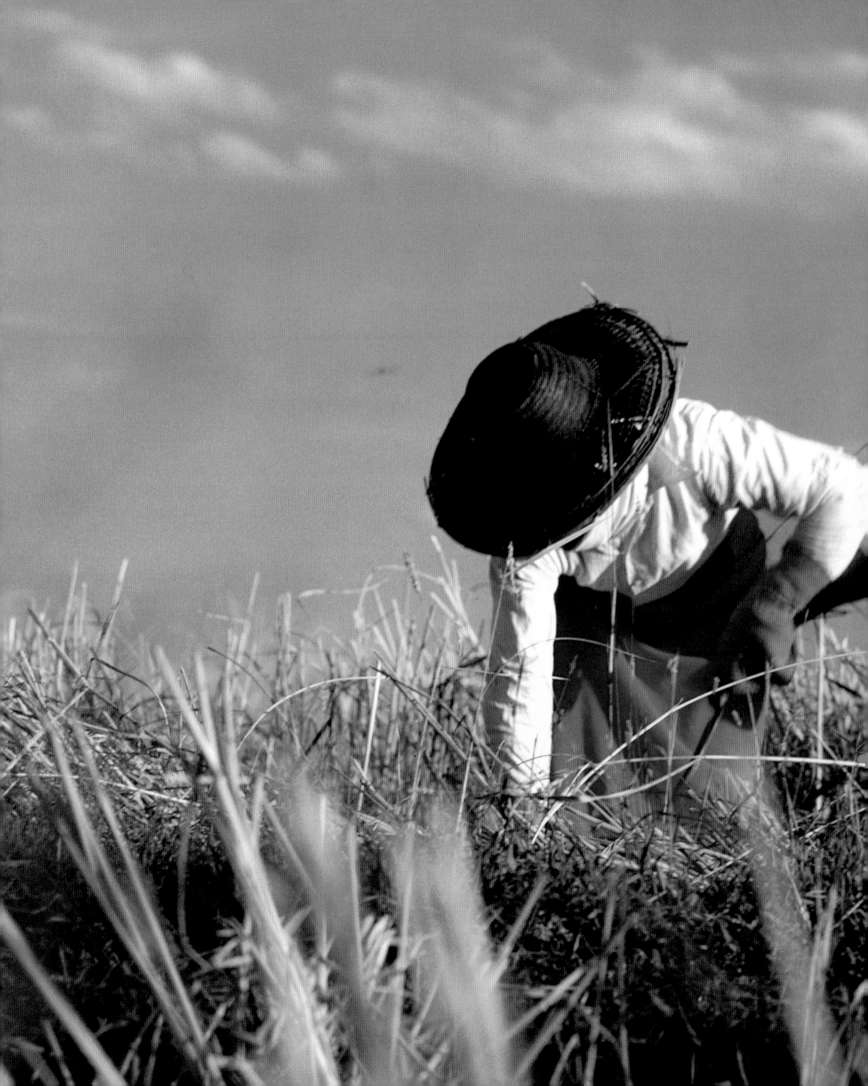

Mon groups, the Palaung, who are hill dwellers practicing both Buddhism and spirit worship. Among the smaller groups of Mon-Khmer descent, the Padaungs and the Wa have become known due to their unusual and exotic customs, as described below. Their small numbers, however, make them not representative of Burmese culture.

In fact, the few thousand Padaungs are one of Burma's smallest ethnic minority groups. They live in the vicinity of Loikaw, capital of Kayah State. Paduang "giraffe women" have necks which appear to have been elongated by copper or brass rings that are worn for life. Young girls begin receiving neck rings at the age of five or six, and twenty pounds of new rings are gradually added as they mature. At the time of marriage, their necks appear to be ten inches long. In actual fact, the collarbones and ribs have been pushed down and the women have been unable to develop substantial neck muscles. Therefore, the rings mostly support the head and are not removed. This now obsolete custom has puzzling and controversial origins. It is believed that the practice developed when larger tribes frequently raided the Padaungs for slaves. By thus deforming all their women, the Padaung men were able to dissuade these potential captors from enslaving them.

Until the 1940s, not much was known about another Mon-Khmer group of several hundred thousand, the Wa. Making their home along the remote Shan State border with China, it was known only that they were headhunters who sacrificed human skulls for fertility purposes. However, in the 1960s, the outside world learned that they had become the main suppliers of opium in the famous Golden Triangle, the source of 60 percent of the world's heroin. Today, this remote and tempestuous region is profitably controlled by the military regime out of Rangoon, Burma's capital.

The Shan: The four million Shan are predominately Buddhist and have played an important role in shaping the mystique of Burma. Shan State offers some of the most beautiful and unspoiled environments in the country. Vast pine forests, deep freshwater lakes, and waterfalls abound in an area that in most places reaches several thousand feet above sea level. The Shans prefer a life of simplicity in harmony with nature and value being far from the urban centers of the plains and delta regions. Buddhist temples and pagodas dot the crests of their rugged hills. A Shan subgroup, the Intha people of Inle Lake, are famous for their leg-rowing technique, which they perform while standing erect and with one hand free. Shan State's awesome Pindaya caves contain tens of thousands of exquisite images of the Buddha, shrouded in centuries of legends. The high-altitude resort of Kalaw and the Shan State capital of Taunggyi at five thousand feet draw many people from the cities during the torrid summer months. Part of Shan State's mystique is due to the great diversity among its peoples.

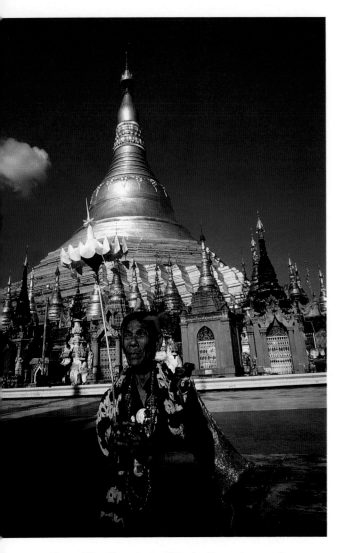

Above: The Shwedagon Pagoda, Burma's most famous Buddhist landmark, rises some 326 feet high in the center of downtown Rangoon. The upper dome of the pagoda is plated with 8,688 solid gold slabs and its tip is richly studded with 5,448 diamonds and 2,317 rubies, sapphires, and topazes. It was built, and then continuously restored and enlarged, by a succession of Burmese kings over a period of two thousand years.

Opposite: During its golden age in the twelfth century, Pagan acquired the name "City of Four Million Pagodas." Today, the village of thirty thousand that marks this ancient capital of Burmese kings has been bulldozed by Burma's military regime to make way for a sprawling tourist resort. The sun-baked plain remains studded with thousands of pagodas, most of them in ruins.

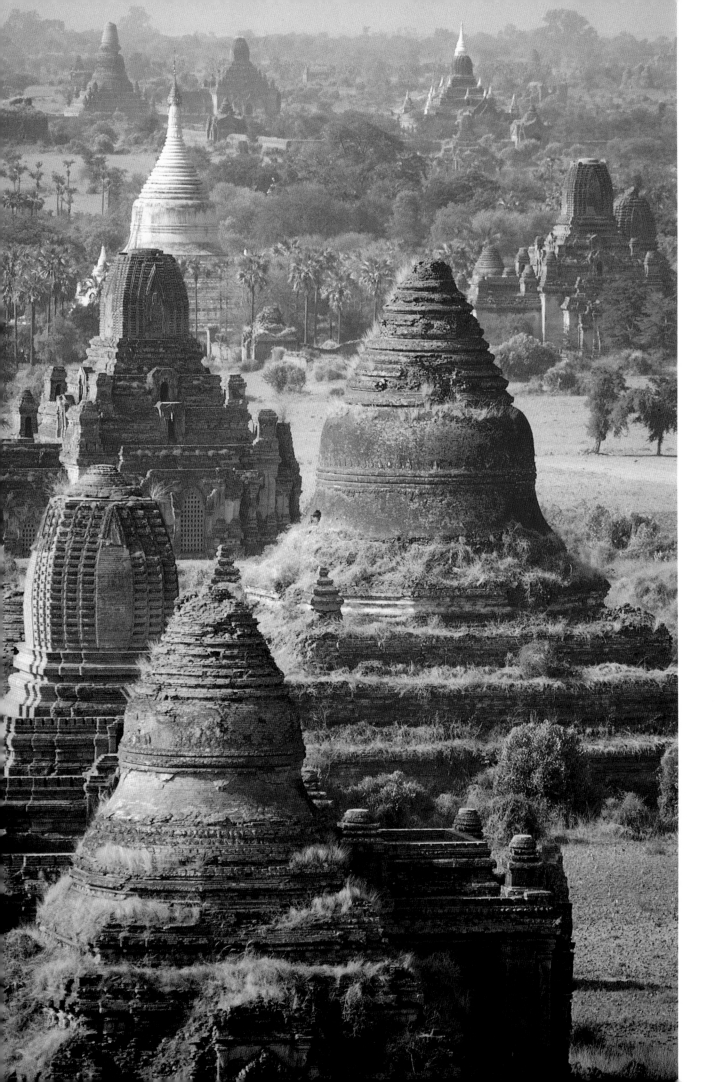

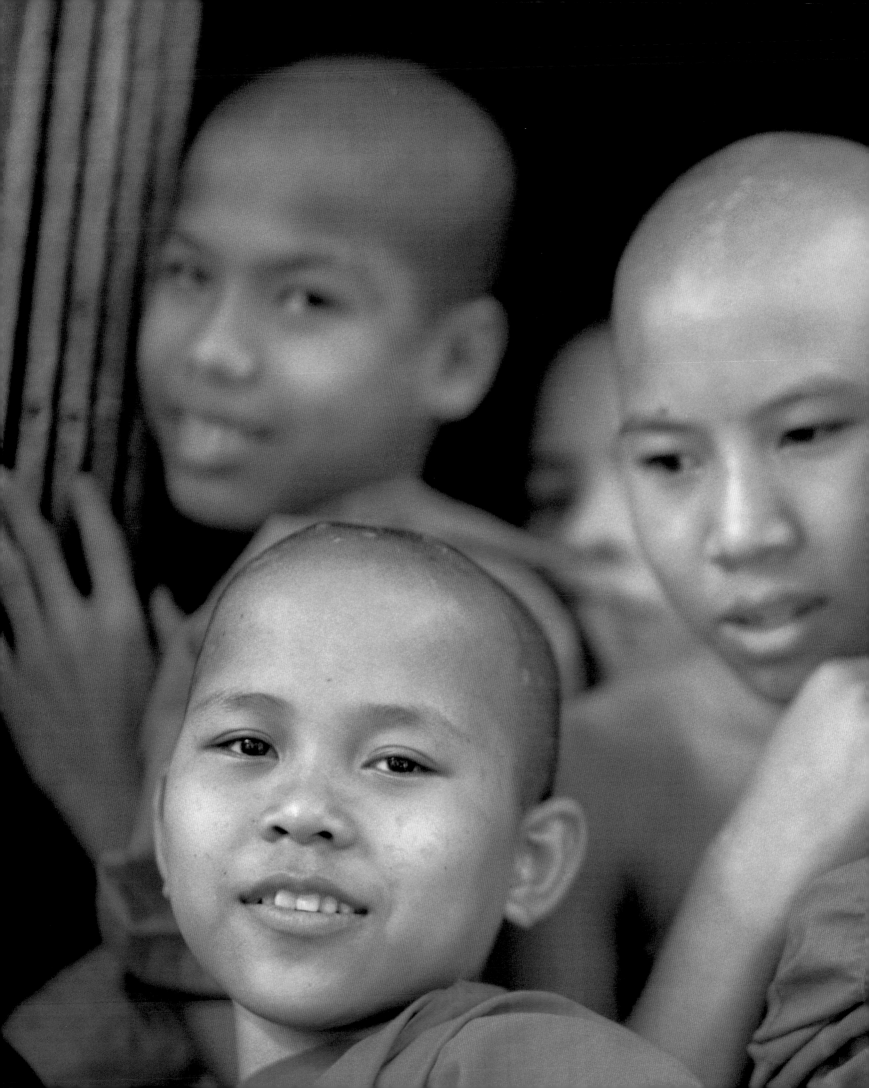

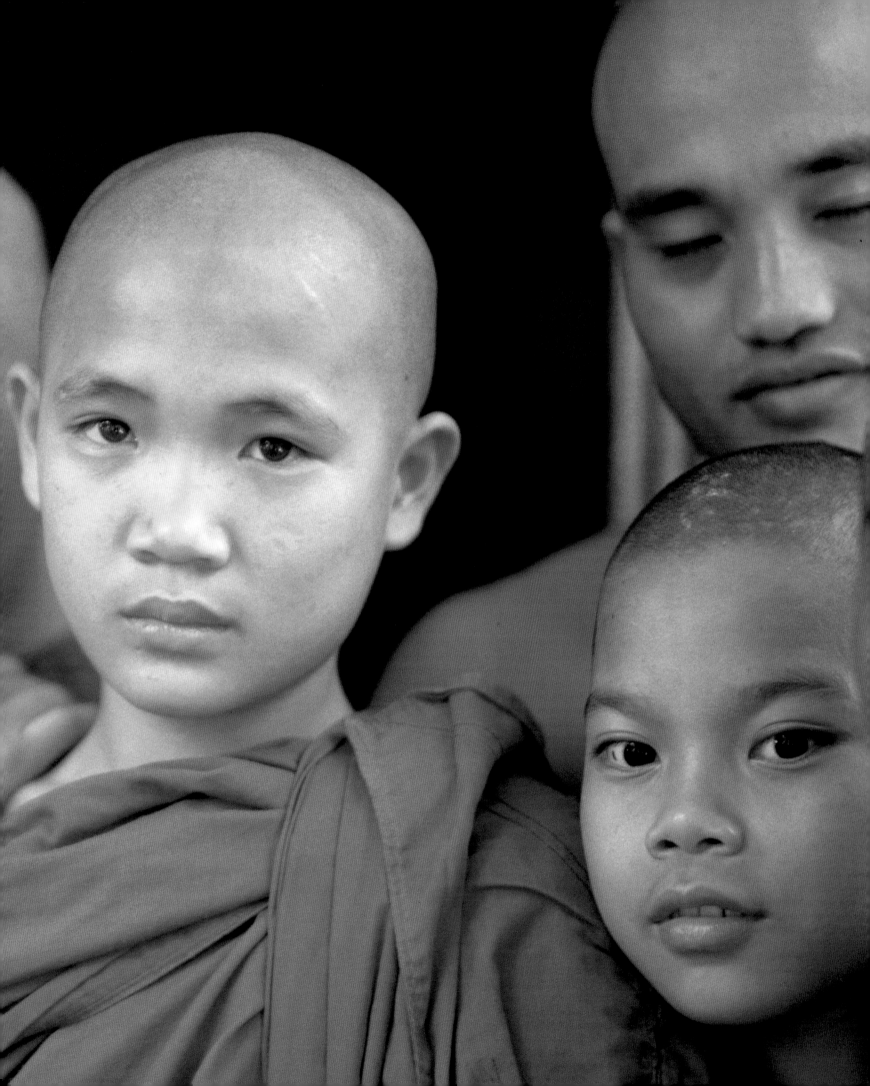

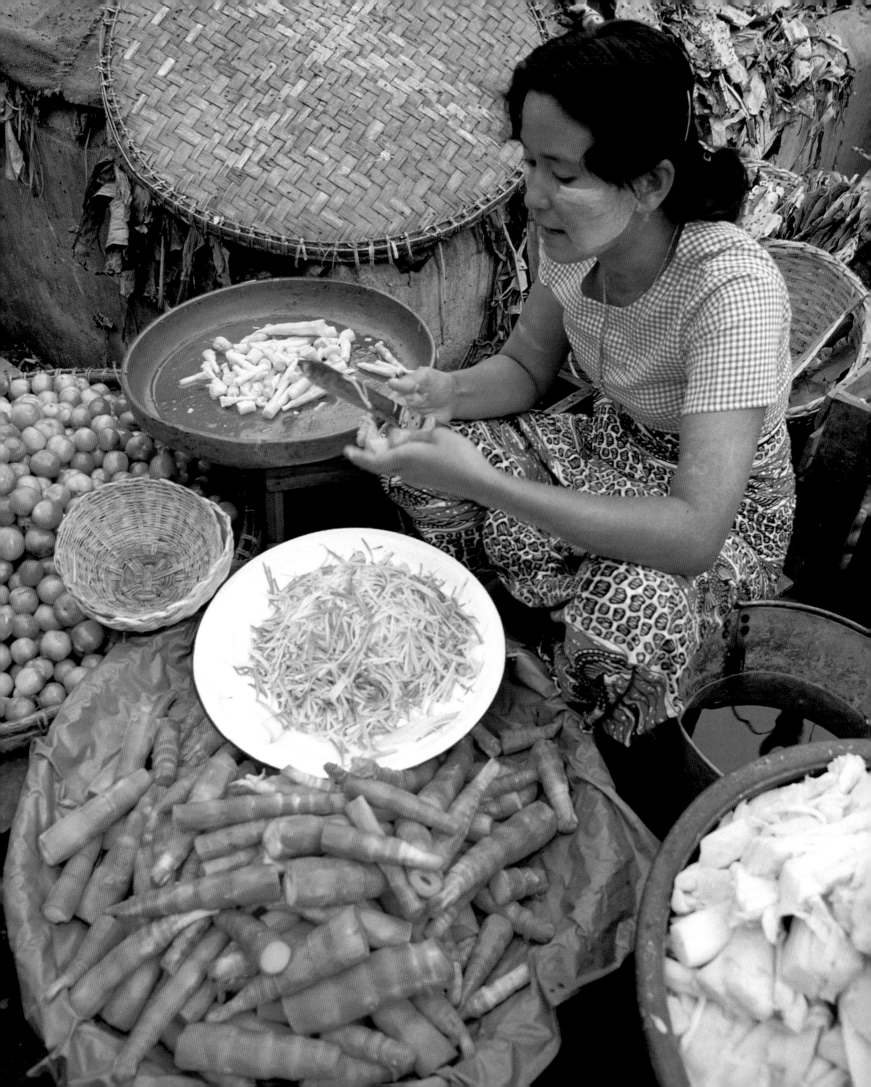

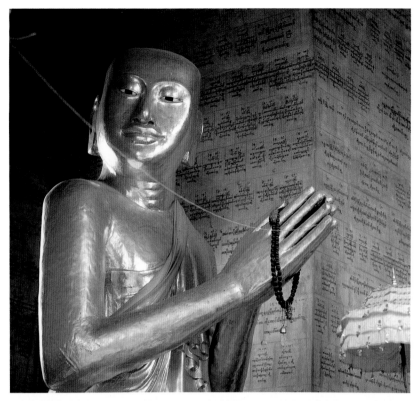

Previous spread: It is customary among Burmese Buddhists that all boys from ages eight to twelve enter a monastery for varying lengths of time to receive their basic religious training.

Opposite: Vegetable and fruit markets are the center of morning activity throughout Burma.

Right: A gold-plated statue of Ananda, the chief attendant of the Buddha. Ananda, meaning the peaceful one, is revered as the embodiment of selfless service.

Below: 85 percent of Burma's forty-two million people live in rural villages.

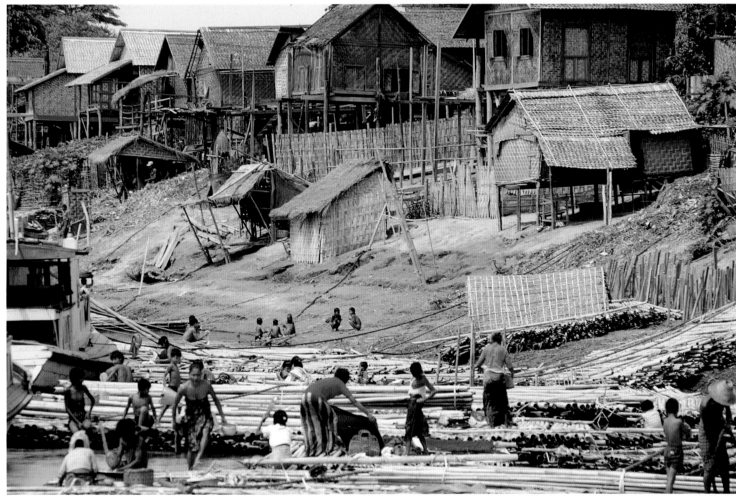

It is estimated that there are twenty-seven major subgroups in Shan State, including the PaO, Palaung, Kachin, Intha, and Danu. There are also thirty-two smaller and relatively unknown hill tribes.

The Karen: There are three recognized groups of Karens: the Pwo (lowland and delta), the Sgaw (hill tribes), and the Bwe (remote mountain peoples). The Karen are a rugged and peace-loving people who have a great appreciation for simplicity. Like the Shans, the Karens are reverential towards the environment. They have developed illustrative stories and legends to explain the power of nature and the necessity of maintaining a high regard for all life forms. Numerous small farming villages built of thatch and bamboo comprise a state of several million inhabitants. The Karen were easily converted by Christian missionaries, partly because of ancient beliefs disposing them to the Christian tradition. Legend said that the Karens' ancestors had lost a book of "holy scriptures" that would someday be returned to them by a "white brother." Their use of the name "Y'we" was notably similar to that of the Hebrew God "Yahweh," and some missionaries believed that they were one of the lost tribes of Israel. There exist uncanny parallels between Bible stories and Karen legends. The Karen are by far the largest Christian group in Burma, although spirit worship and Buddhism still exist among some Karen groups.

The Kachin: The mountains of Kachin State, in the remote far north of Burma, are home to an astounding array of hill tribes. Although the label Kachin is often indiscriminately applied to any inhabitant of Kachin State, true Kachins are members of the Jinghpaw group, the best known of the Kachin-language groups. Marus, Yaywins, and Lisus are among other Kachin groups sharing the territory. The Kachin are primarily animistic, but followers of Buddhism and Christianity exist within the culture. The animistic Kachin believe that there is always a spirit behind every good or evil action, and that all acts can be explained in that way. Shamans perform rites at village shrines to make the appropriate offerings and communications to these powerful spirits. The Kachin are well known throughout Burma for developing elaborate dances, which play an important role in feasts and festivals.

The Arakanese: The state of Arakan along Burma's coast is partly inhabited by the Rohingyas, a distinct cultural group of Burmese Muslims descended from Arab, Moorish, Mughal, and Bengali merchants who arrived on the Arakan coast beginning in the seventh century. Rohingyas share the Arakan State with the Buddhist Rakhine, of Tibeto-Burman stock. After fifteen hundred years of living in independent kingdoms, the Arakanese came under Burman conquest in the eighteenth century, which marked the beginning of years of tension between the two groups. Arakanese do not trust Burmans;

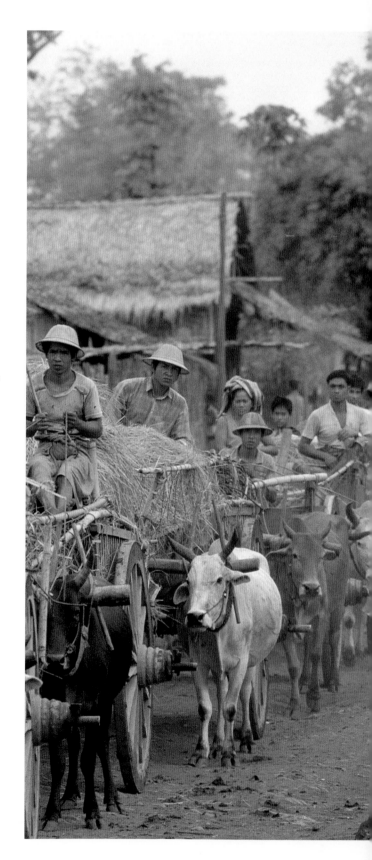

Burmese are riddled with prejudice against the Muslim minority, whom they label "foreigners." Rohingyas have been persecuted by the Buddhist Arakanese and the Rangoon government at various times in recent history. Rohingyas were one of only a few ethnic minorities excluded from the new union formed under the 1948 constitution. In 1988, Rangoon's armies forced 200,000 Rohingya refugees into Bangladesh, and renewed atrocities by Ne Win's regime sent an additional 220,000 fleeing across the border in 1992.

The Chins: The Chins are the least known group and have been only minimally affected by foreign influence. The obscurity of these peoples is due to their isolated mountain habitat as well as the great diversity of subsects found among them. Comprising a population of 280,000, the Chins speak at least forty-four dialects. Like the Kachins, most Chins are animistic—worshiping aspects of nature and spirit gods as the rulers of their destiny. Throughout Burma, the Chins are highly regarded as skilled fisherman, hunters, and weavers of fine fabric and blankets.

Buddhism: The Heart of the Burmese People

Throughout central Burma and among 85 percent of the Burmese people, the teachings of the Buddha are thoroughly interwoven into the fabric of everyday Burmese life. Buddhism has dramatically shaped Burmese culture and civilization. In fact, Burma, like Tibet, is considered by many to be one of the most profoundly Buddhist countries in the world. Within Burma's several thousand monasteries reside approximately 800,000 monks, novices, and nuns, and most villages are centered around at least one monastery (*kyaung*). No Burmese Buddhist household is complete without a small Buddhist shrine, which occupies a prominent place in the home.

The Burmese practice Theravada ("the Pure Land") Buddhism, an ancient sect that adheres most closely to the original teachings of the Buddha spanning 2,300 years. Buddhism is based on the Four Noble Truths of the Buddha's enlightenment. The First Noble Truth teaches that the nature of life is suffering, which is unavoidable; the Second Noble Truth explains that the root cause of suffering is desire and attachment; the Third Noble Truth espouses that there is a freedom beyond the causes of suffering; and the Fourth Noble Truth explains a path beyond attachment known as the Middle Way, or the Eightfold Path. The eight "right" actions of this path are: right understanding, right thought, right speech, right action, right livelihood, right effort, right mindfulness, and right concentration. The final goal is the liberation from greed, anger, and delusion into Nibbana (Nirvana)—supreme enlightenment.

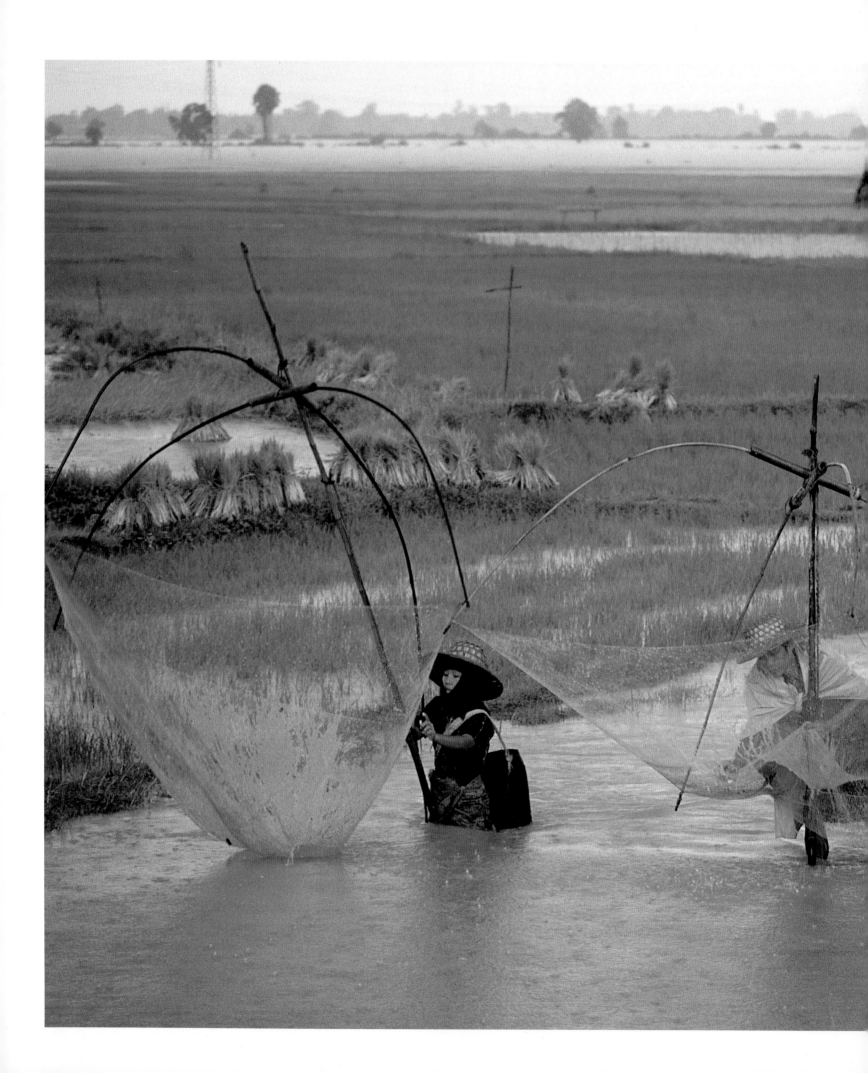

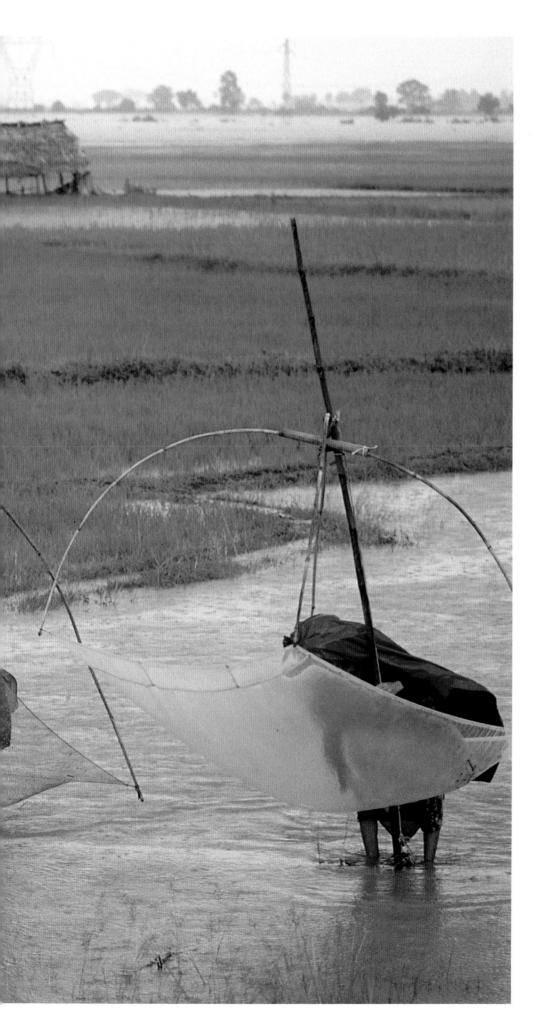

If we are to be free we must make each person we meet our ultimate object of reverence.

Burmese Buddhist proverb,
fourteenth century

Net fishing in the shallow waters of irrigated fields is common in the vast delta region of southern Burma.

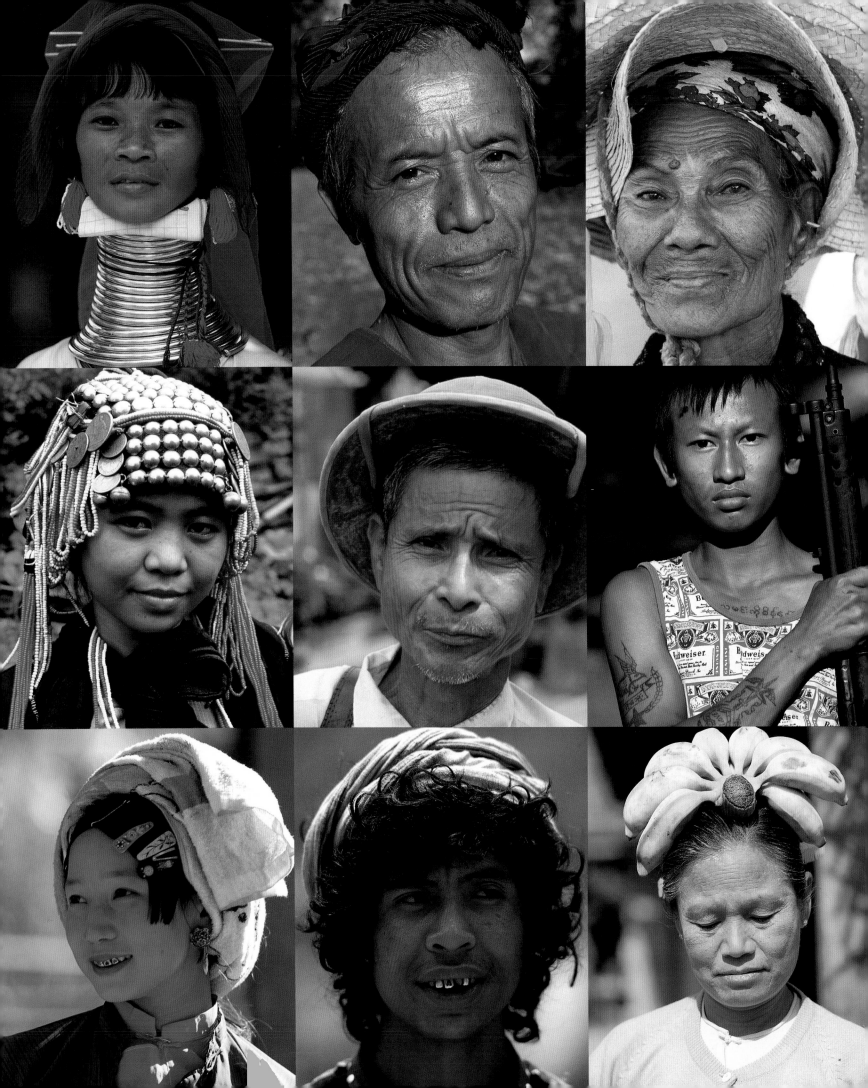

Burmese Buddhists believe strongly in the doctrine of karma: the law of cause and effect, which holds that each rebirth is the result of the actions of a previous life. Calling into question whether Buddhism is actually a "religion," it does not teach belief in a god or supreme being; one is fully responsible for one's own actions. The Burmese are a generous people, partly due to their desire to earn merit toward their next life through present good deeds.

Almost every Burmese man enters the monastery at least three times during his lifetime—once for his boyhood initiation (*shin-pyu*) and two more times as an adult. Monks (*pongyi*) are required to abide by the strictest code of discipline, which includes celibacy, the renunciation of possessions, no solid food after twelve noon until the following morning at sunrise, and a vow not to injure any living thing, even insects. The *pongyi* sets out every dawn with his alms bowl to beg for food. A donor is grateful for the opportunity to earn merit by providing sustenance for one in service to the Dharma.

Burmese live every phase of their lives in accordance with a profound teaching, and cannot be considered uncivilized. It's wrong to ridicule them just because they don't have the kind of knowledge we do. They possess something marvelous that we can't even begin to understand.

Michio Takeyama, *Harp of Burma*, 1946

Opposite and above: At least sixty-seven distinct indigenous groups live in Burma's forests, mountains, and plains. In the early 1900s, a British survey reported that 242 separate languages and dialects were spoken.

A NATION EXPLODES

By July 1988, an intolerance for human-rights abuses, economic decline, and an unaccountable military regime had led to severe social unrest. During the first half of the year, thousands of people, organized by university students, marched peacefully in the streets of Rangoon. They called for an interim civilian government, introduction of a democratic multiparty system with fair elections, and a restoration of basic civil liberties. Ne Win, operating from behind the scenes to influence the military, responded by sending in troops, which suppressed the demonstrations–arresting, torturing, and killing indiscriminately. (Earlier in July, bowing to the pressure of the uprisings, Ne Win had resigned, although he continued to operate a puppet government from behind the scenes, through his unpopular successor, General Sein Lwin, the commander in chief of the military.) In response to the students' leadership role in the marches for democracy, all universities were closed by the government and remained so until May 1991.

The momentum for democratic change gathered; in August 1988 Burma exploded onto the front pages of almost every major newspaper around the world. With the people seething from the recent killings in addition to decades of repression and economic devastation, university students led millions on peaceful marches for democracy in all major cities. Turning to American democracy as their symbol and their hope, large crowds gathered outside the U.S. Embassy beneath the American flag. As the marches gathered momentum, Sein Lwin prepared his response by sending thousands of troops into the street. "It was an incredible moment in our lives," a female student demonstrator later reported. "We so desperately wanted freedom and democracy. The moment had come when we thought it would be possible to come out from under the boot of military oppression that had trampled us since we were young children."

Events reached a climax on August 8 (later known as the Massacre of 8/8/88), the day on which a nationwide general strike was organized by the All-Burma Students Democratic League. Peaceful demonstrations occurred throughout the day, with an army presence visible and threatening, although temporarily restrained. "We in turn, many thousands of us, knelt down in front of the soldiers," the same student continued. "We sang to them, 'We love you; You are our brothers. All we want is freedom. You are the people's army; come to our side... All we want is democracy.' Then, at 11:45 P.M., the heavily armed troops began a four-day massacre by firing into crowds of men, women, and children gathered outside Rangoon's city hall."

The results were devastating. "They had orders to fire and they did," the student went on to say. "Many students, some friends, and some of my family members were shot dead on the spot. We had no idea

Above: A Burmese soldier on alert in Rangoon only hours before orders were given to fire on unarmed demonstrators.

Opposite: On August 8, 1988, millions peacefully marched in all major cities throughout the country demanding democracy, free and fair multiparty elections, and an end to the oppressive dictatorship that had gripped the nation for twenty-six years.

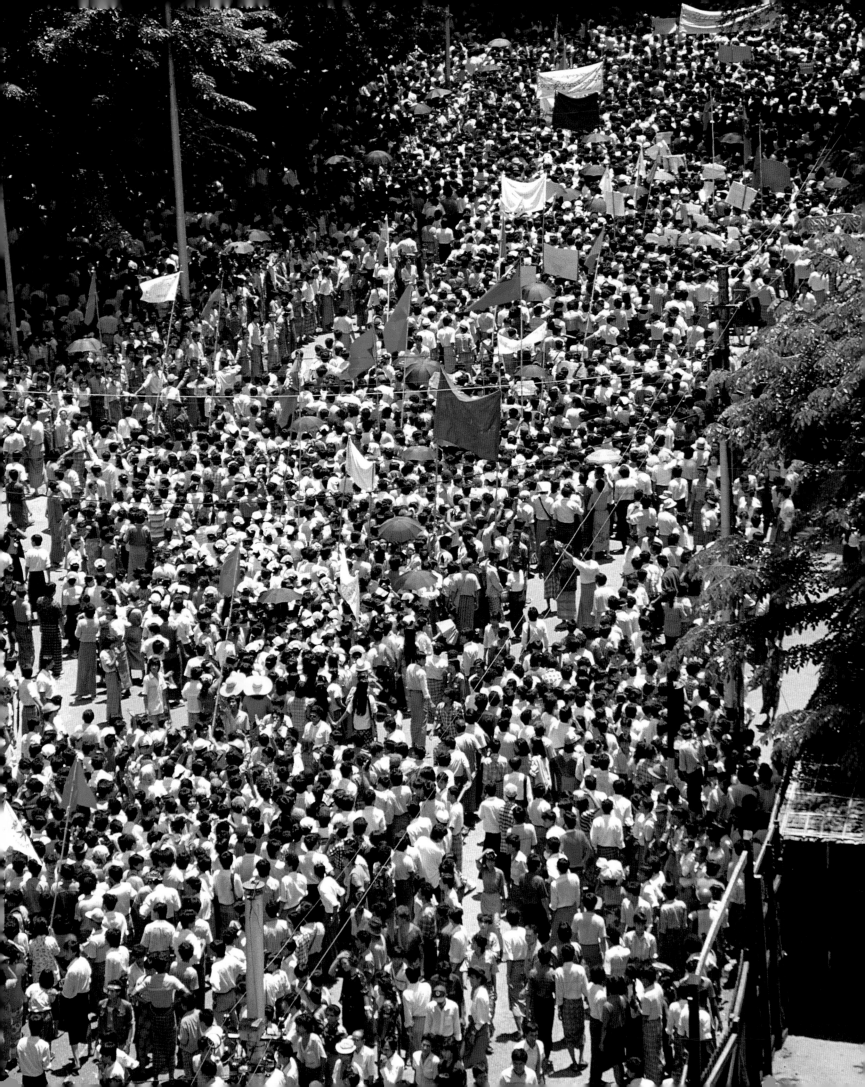

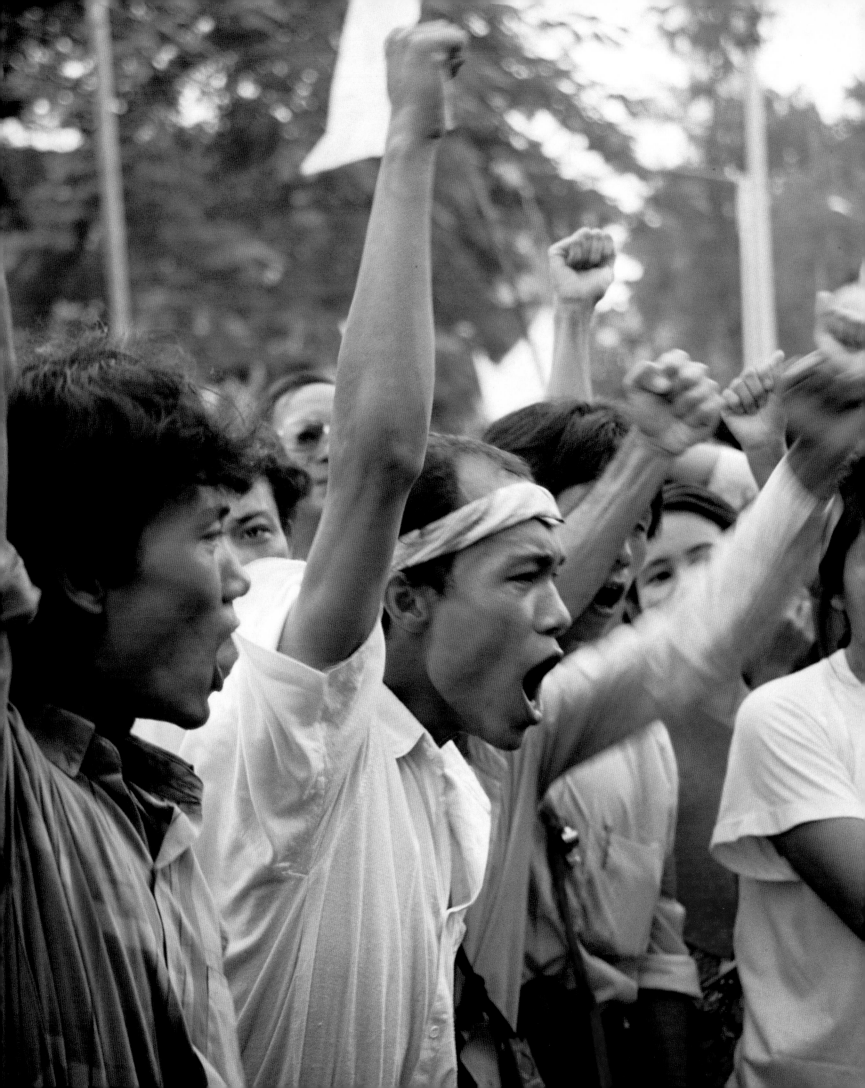

Opposite: University students were at the forefront of the mass demonstrations.

Below: As the nonviolent demonstrations gathered momentum, the military prepared their response by sending heavily armed soldiers onto the streets of Rangoon.

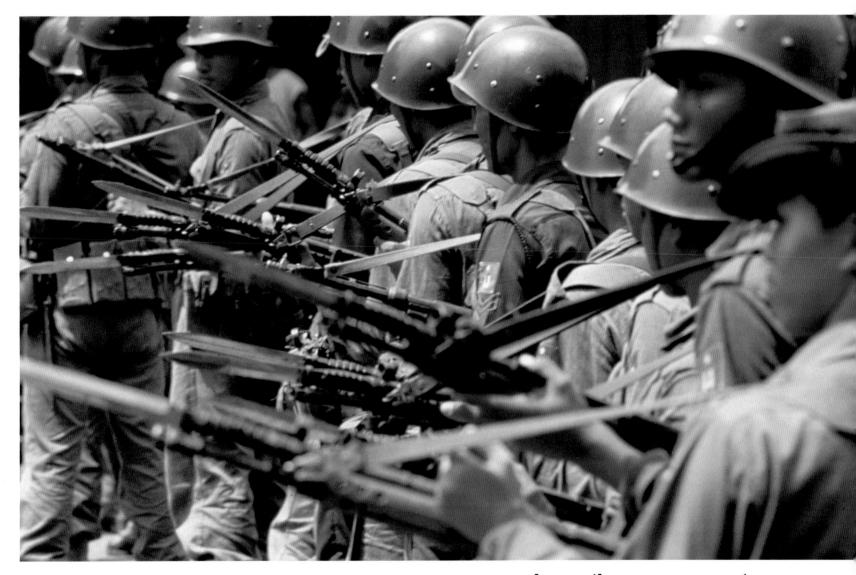

...as long as there are governments whose authority is founded on coercion rather than on the mandate of the people...there will continue to be arenas of struggle where victims of oppression have to draw on their own inner resources to defend their inalienable rights as members of the human family.

Aung San Suu Kyi
Nobel Peace laureate, 1991

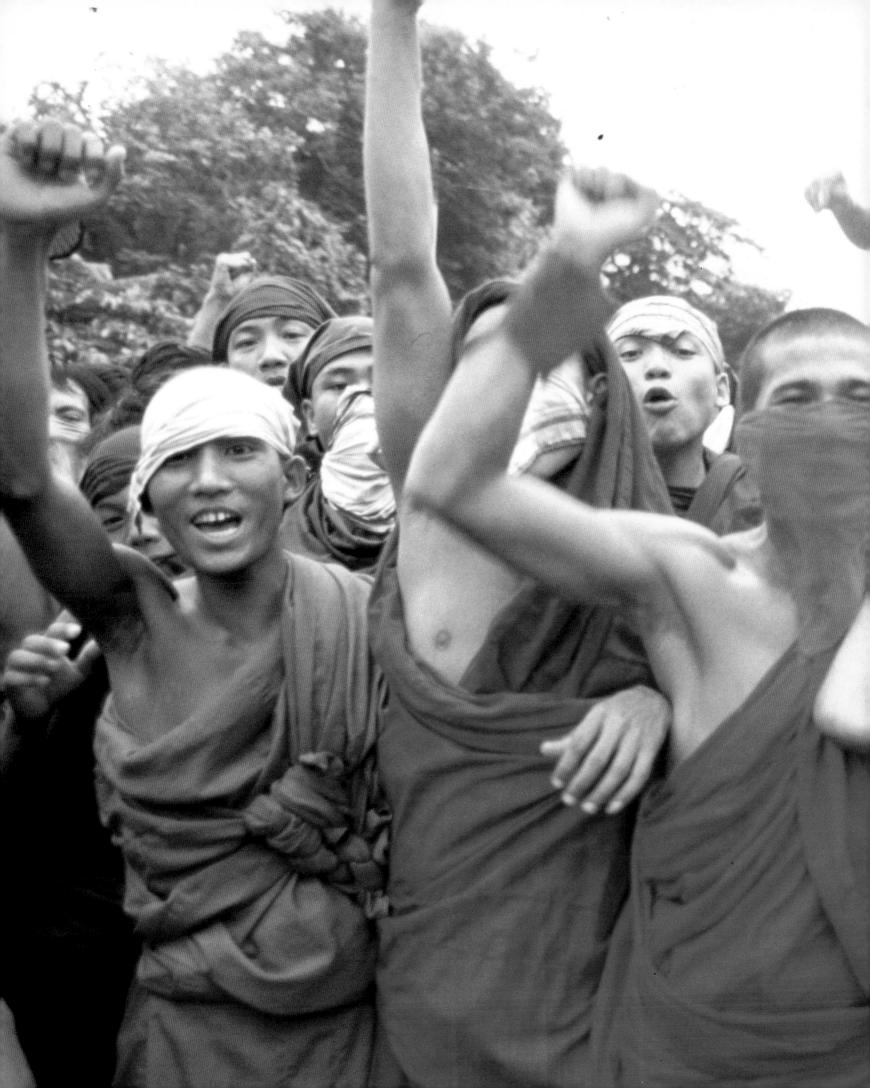

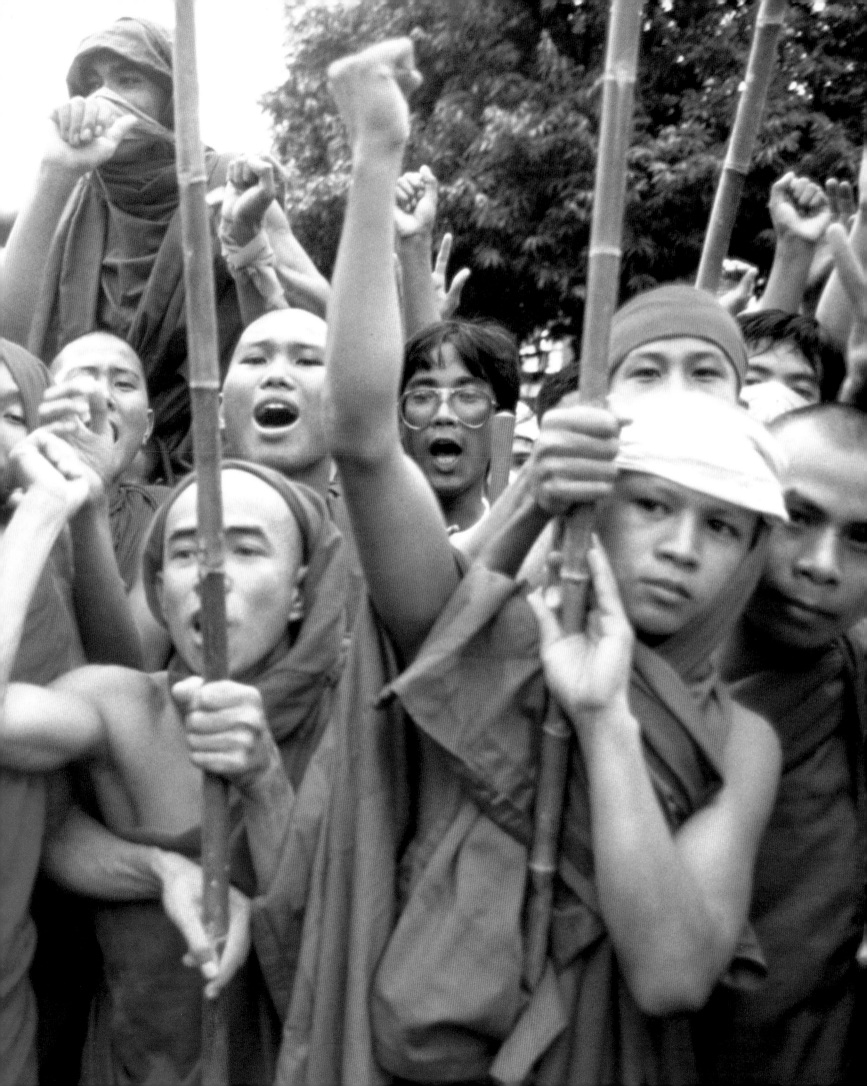

Previous spread: Unprecedented in the Sangha (Buddhist monastic community), thousands of Buddhist monks joined the demonstrations.

Fearlessness may be a gift but perhaps more precious is the courage acquired through endeavor, courage that comes from cultivating the habit of refusing to let fear dictate one's actions, courage that could be described as "grace under pressure"—grace which is renewed repeatedly in the face of harsh, unremitting pressure.

Aung San Suu Kyi
Nobel Peace laureate, 1991

that our own people would kill us. There was blood everywhere. Loud screams and the cracking of gunfire echoed loudly. People began falling down everywhere." On August 10, troops fired in front of Rangoon General Hospital, killing doctors, nurses, and Red Cross workers and wounding others who were pleading with them to stop. Injured victims were denied medical care. Eyewitnesses describe soldiers entering the crowded emergency room at Rangoon General and shooting injured students on stretchers and in hospital beds. In North Okkalapa, a suburb of Rangoon, bodies were thrown into trucks and taken to Kyandaw Cemetery, where live students were cremated along with the dead. Soldiers blindly carrying out the orders were convinced by their superiors that the students were "communist insurgents." They were ordered to drink a potent whisky in the morning and evening in order to obliterate any moral consciousness about killing their own countrymen. After the fact, ABC's *Nightline* reported: "Authorities announced that five hundred people had been killed. Foreign diplomats and others on the scene said the number was closer to ten thousand."

On August 12, Sein Lwin resigned after eighteen days in office. Following the brutalities he incurred, he had become known to the Burmese as "the Butcher." Even in the midst of the carnage and a city in flames, people actually danced for joy in the streets of Rangoon to celebrate Sein Lwin's resignation. Dr. Maung Maung was installed as the next puppet president on August 19, lasting until Ne Win staged a military coup on September 18. In this final month before the September coup, Burma's citizenry had become entirely unified for democracy and, due to the withdrawal of armed troops from the streets, elated by the expectation that their "revolution" was on the verge of success. A harsh military crackdown followed the coup, in which thousands of demonstrators were once again massacred on the streets as a handful of journalists and diplomats watched help-lessly from the windows of the U.S. Embassy.

In the aftermath of the massacres, an eerie calm descended over the city. Some students went underground to continue the struggle for democracy; many others fled for their lives with the hope of finding refuge in neighboring Thailand. The U.S. Senate and other government bodies condemned the regime and its killing of Burma's innocent people. Nonetheless, during the months following the uprisings, thousands were arrested and given long prison sentences without trial. Many were tortured and raped. Approximately ten thousand students and members of the intelligentsia ended up in camps along the Thai-Burma border, where they were welcomed and supported by the ethnic minorities. The All-Burma Students' Democratic Front (ABSDF) was formed and began organizing a resistance movement.

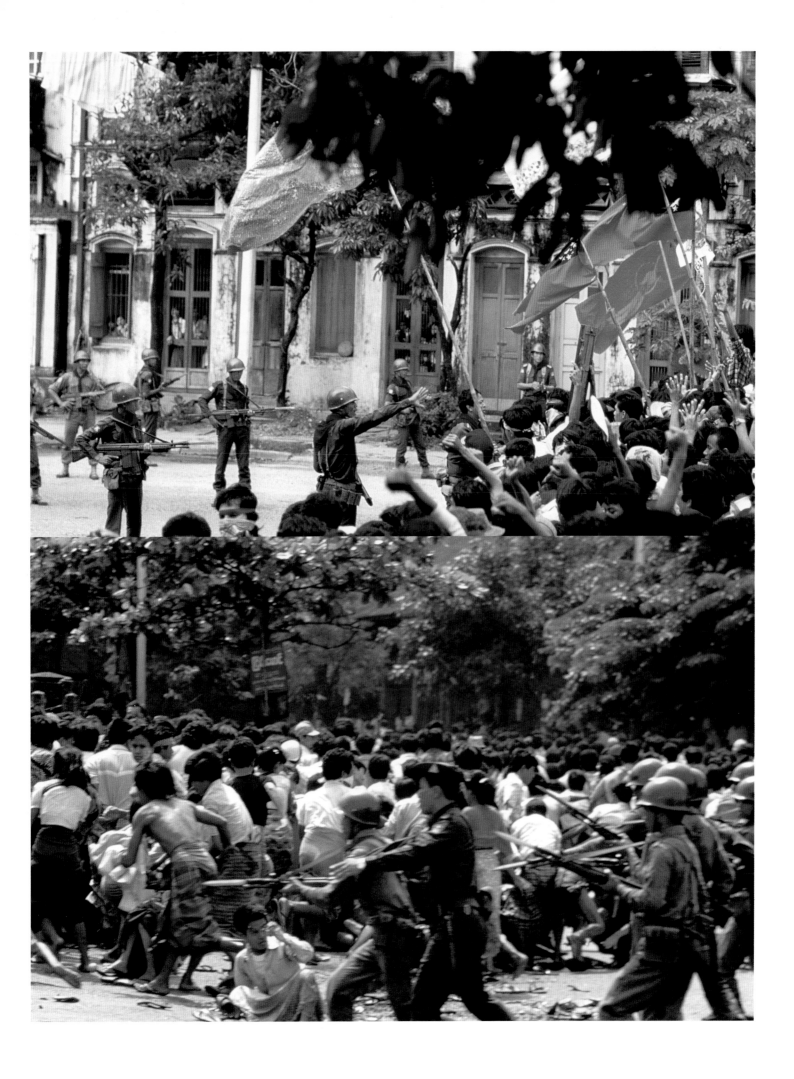

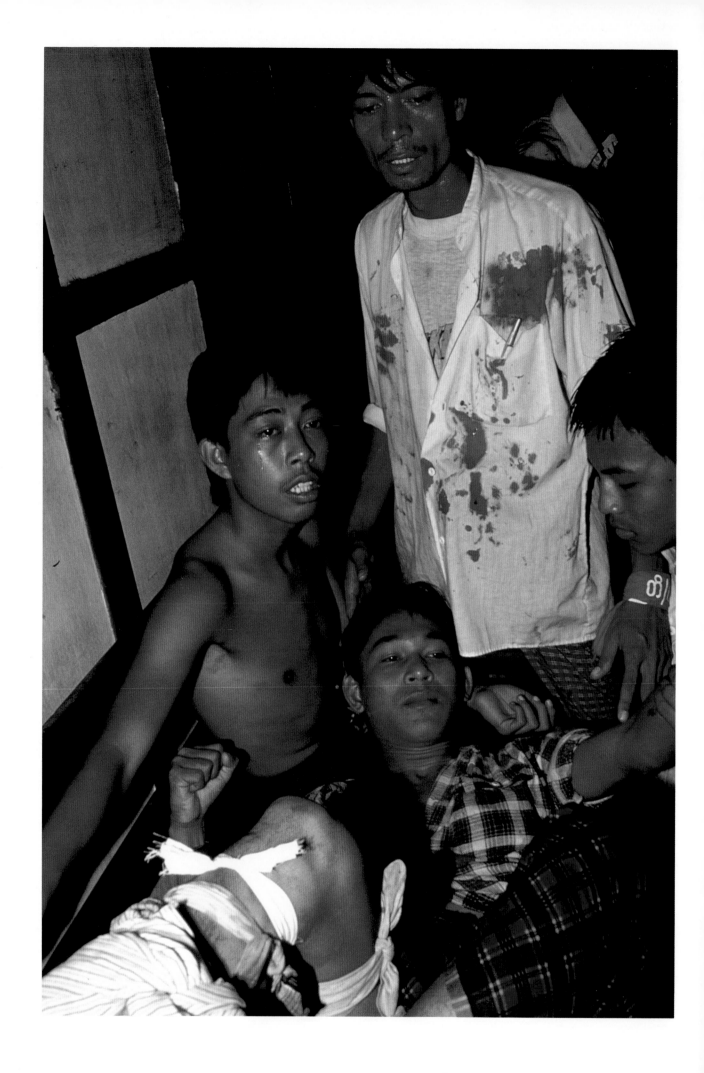

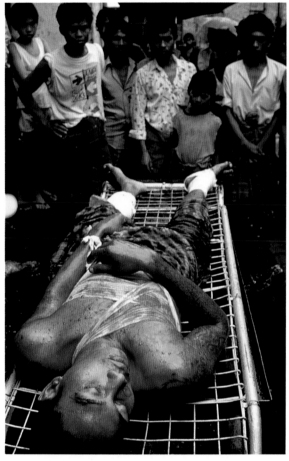

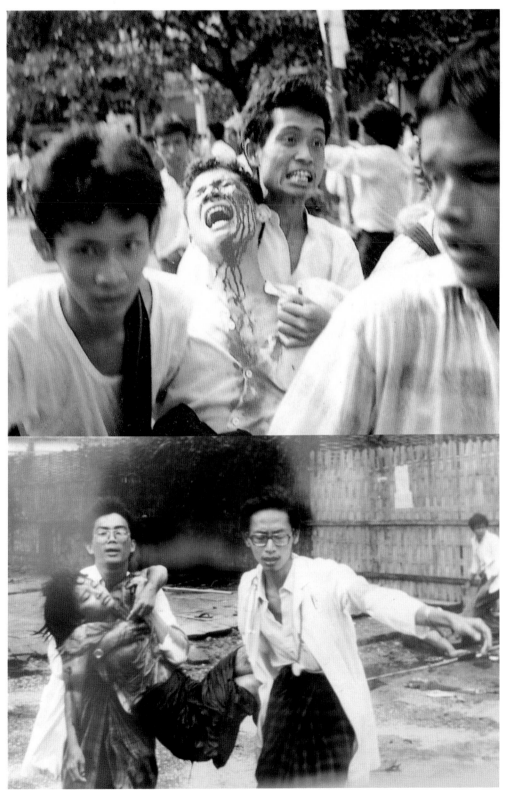

By mid-September, the people of Burma believed their country to be on the verge of democracy as a result of their determined and well-organized national civil disobedience. Outraged by an unexpected military coup of September 18, they responded by immediately renewing massive demonstrations. The harsh and swift military reaction was more brutal than the Massacre of 8/8/88, as additional thousands were shot in the streets. Opposite, clockwise from left: Several wounded students, along with hundreds of others, await treatment at Rangoon General Hospital; a wounded demonstrator; a victim of street massacre; a fifteen-year-old girl was shot in front of the U.S. Embassy and later died. Medics risked their own lives to rescue comrades lying dead and wounded on the street.

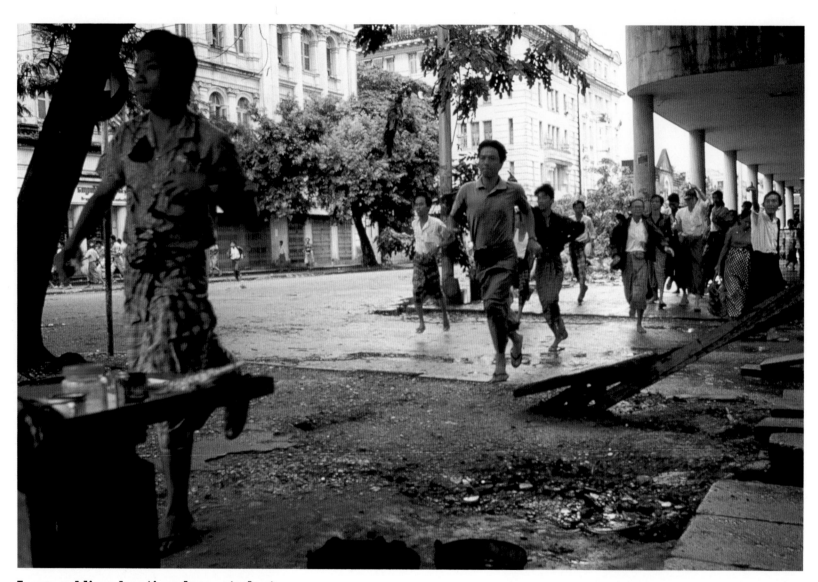

I saw soldiers hunting down students on the streets, and people huddled behind trees being picked off by snipers in buildings across the road.

Burton Levin
United States Ambassador to Burma, 1991

Above: During the massacres following the "September 1988 coup," people ran from the bullets of soldiers and snipers in front of the U.S. Embassy in Rangoon.

Opposite: A deadly calm descended over Rangoon after the killings. Military trucks swept through the city collecting the unidentified bodies of the dead for cremation.

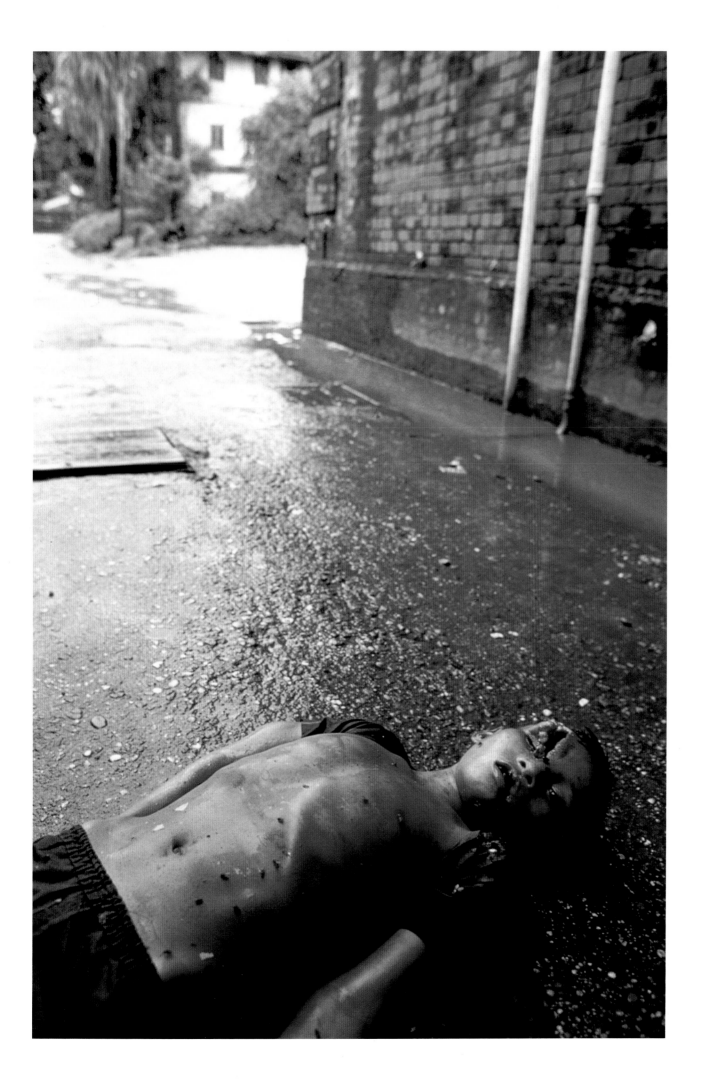

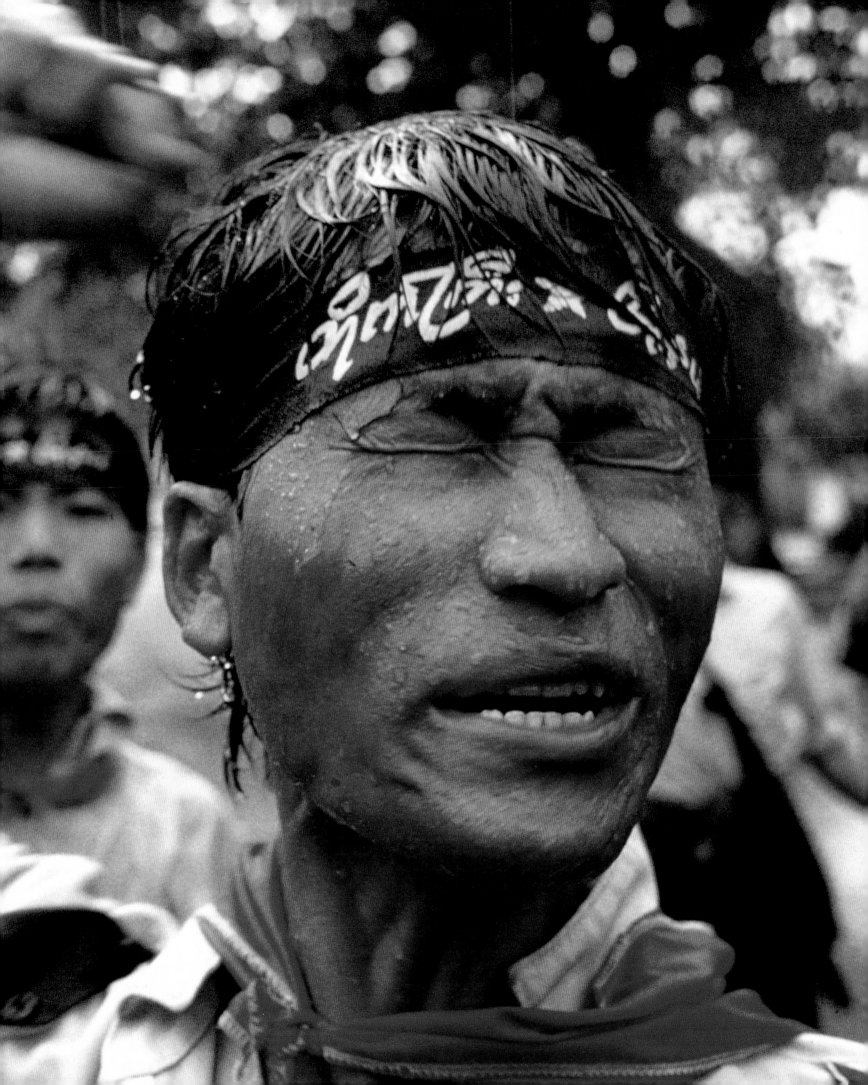

GRACE UNDER PRESSURE

Even though thousands fled to the jungles to avoid capture, the momentum of the democracy movement could not be crushed. Unexpectedly, Aung San Suu Kyi (pronounced *awng sahn soo chee*), the forty-three-year-old daughter of Burma's national-independence hero Aung San, publicly began to articulate the people's long-cherished ideal of democratic freedom and personal dignity. In her inspired campaign, she followed in the footsteps of Gandhi and Martin Luther King Jr. by bringing the principles of nonviolence and civil disobedience to the forefront of her movement. Her essential message of self-responsibility, rooted in Buddhist philosophy, developed into a high-minded political ideology that challenged the politics of oppression and intimidation.

"It is not power that corrupts, but fear," Aung San Suu Kyi wrote in her most famous essay, "Freedom from Fear," written during the time of the demonstrations. "Fear of losing power corrupts those who wield it, and the fear of the scourge of power corrupts those who are subject to it." She continues, "Fearlessness may be a gift but perhaps more precious is the courage acquired through endeavor, courage that comes from cultivating the habit of refusing to let fear dictate one's actions, courage that could be described as 'grace under pressure'—grace which is renewed repeatedly in the face of harsh, unremitting pressure."

On September 18, 1988, just when democratic changes seemed imminent, Ne Win commandeered the army from behind the scenes to take over the country in a staged "coup" and turned over the rule of Burma to a nineteen-member State Law and Order Restoration Council (SLORC). The council was headed by General Saw Maung and Secretary Khin Nyunt, already nicknamed "the Torturer" by the people. The SLORC reinstated martial law: Gatherings of more than four people were punishable by imprisonment; demonstrations were outlawed; criticism of the SLORC was forbidden; a nighttime curfew was imposed; TV, radio, and newspapers continued to be controlled by the state; and military tribunals replaced civil courts, where summary executions were common. Fanning the flames of an already embittered nation following the August massacres, many thousands were killed and arrested as a result of an immediate SLORC crackdown.

Yet the SLORC dangled a carrot to appease the outrage by announcing that they would hold "free and fair" multiparty elections in the spring of 1990. Within three months, over two hundred parties had registered with the SLORC election committee. The strongest and most popular party was the National League for Democracy (NLD), founded by former Chairman and General U Tin Oo and General Secretary Aung San Suu Kyi.

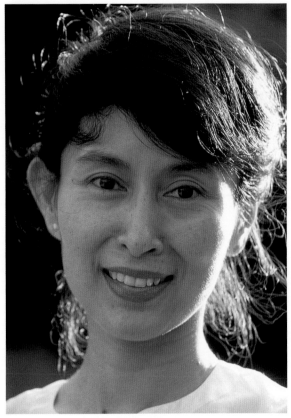

Above: Influenced by the legacy of her father, Aung San Suu Kyi began her public support of her country's struggle for democracy and human rights on August 26, 1988.

Opposite: Four young men listened intently at a rally led by Aung San Suu Kyi. Following the brutal crackdown by the military in 1988, fear and shock gripped the people of Burma. They united behind Aung San Suu Kyi, their only source of hope and inspiration.

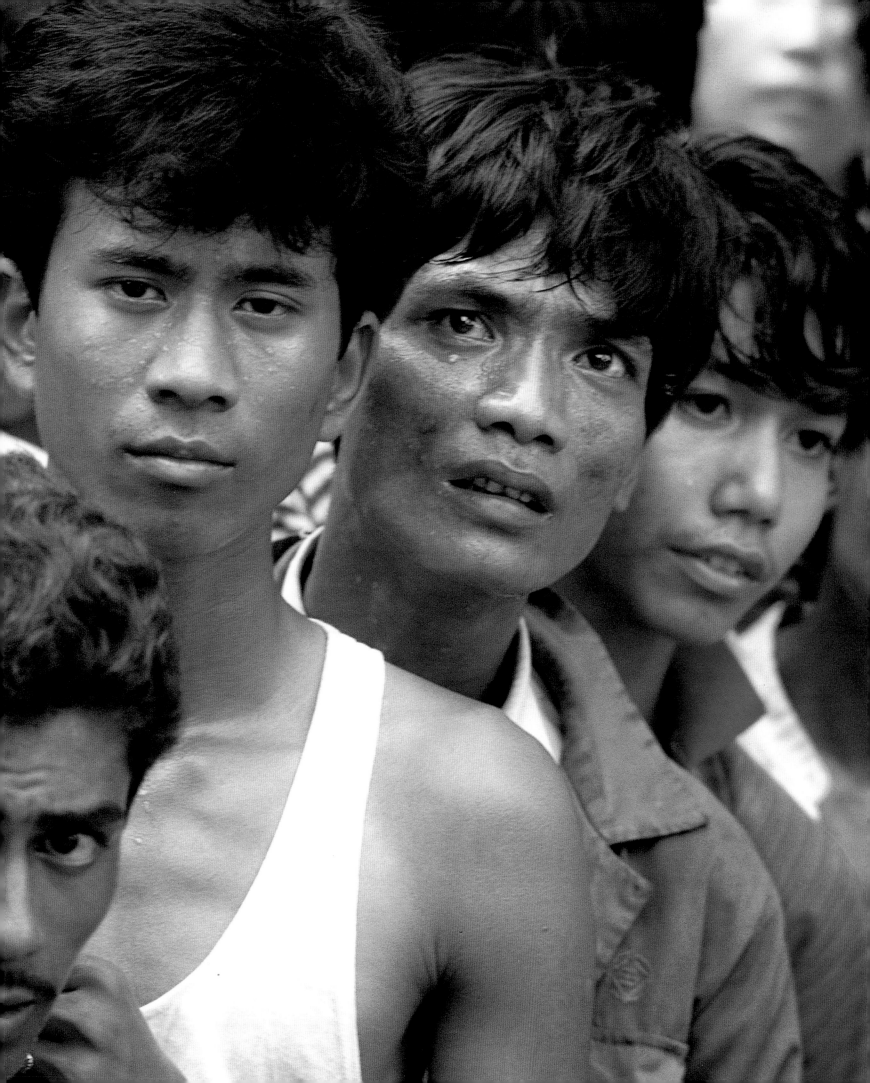

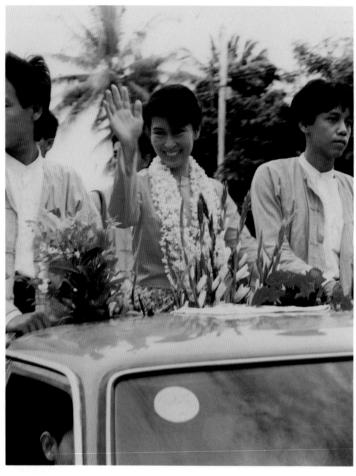

Above: Aung San Suu Kyi traveled extensively throughout the country, giving hundreds of speeches often to crowds of thousands, in an attempt to unite the people and reinstill their courage in achieving their long-sought goal of freedom. She was loved and revered by the Burmese people in their country's time of darkness.

Clockwise from top right: In courageous defiance of the military edict forbidding gatherings of more than four, people turned out in mass to listen to Aung San Suu Kyi wherever she spoke; As Aung San Suu Kyi gained in popularity, military harassment of her campaign escalated. As seen in this rare photo, she is trailed by an armed government soldier; Aung San Suu Kyi with her British husband, Michael Aris, in 1973.

The quintessential revolution is that of the spirit, born of an intellectual conviction of the need for change in those mental attitudes and values which shape the course of a nation's development. A revolution which aims merely at changing official policies and institutions with a view to an improvement in material conditions has little chance of genuine success.

Without a revolution of the spirit, the forces which produced the iniquities of the old order would continue to be operative, posing a constant threat to the process of reform and regeneration. It is not enough merely to call for freedom, democracy, and human rights. There has to be a united determination to persevere in the struggle, to make sacrifices in the name of enduring truths, to resist the corrupting influences of desire, ill will, ignorance, and fear.

Among the basic freedoms to which men aspire that their lives might be full and uncramped, freedom from fear stands out as both a means and an end. A people who would build a nation in which strong democratic institutions are firmly established as a guarantee against state-induced power must first learn to liberate their own minds from apathy and fear.

Aung San Suu Kyi
Nobel Peace laureate, 1991

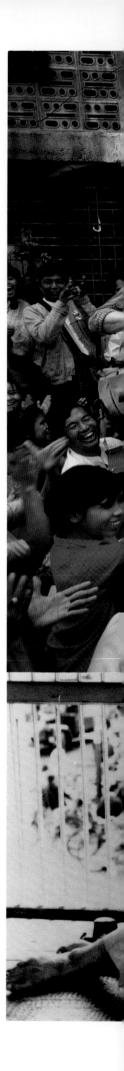

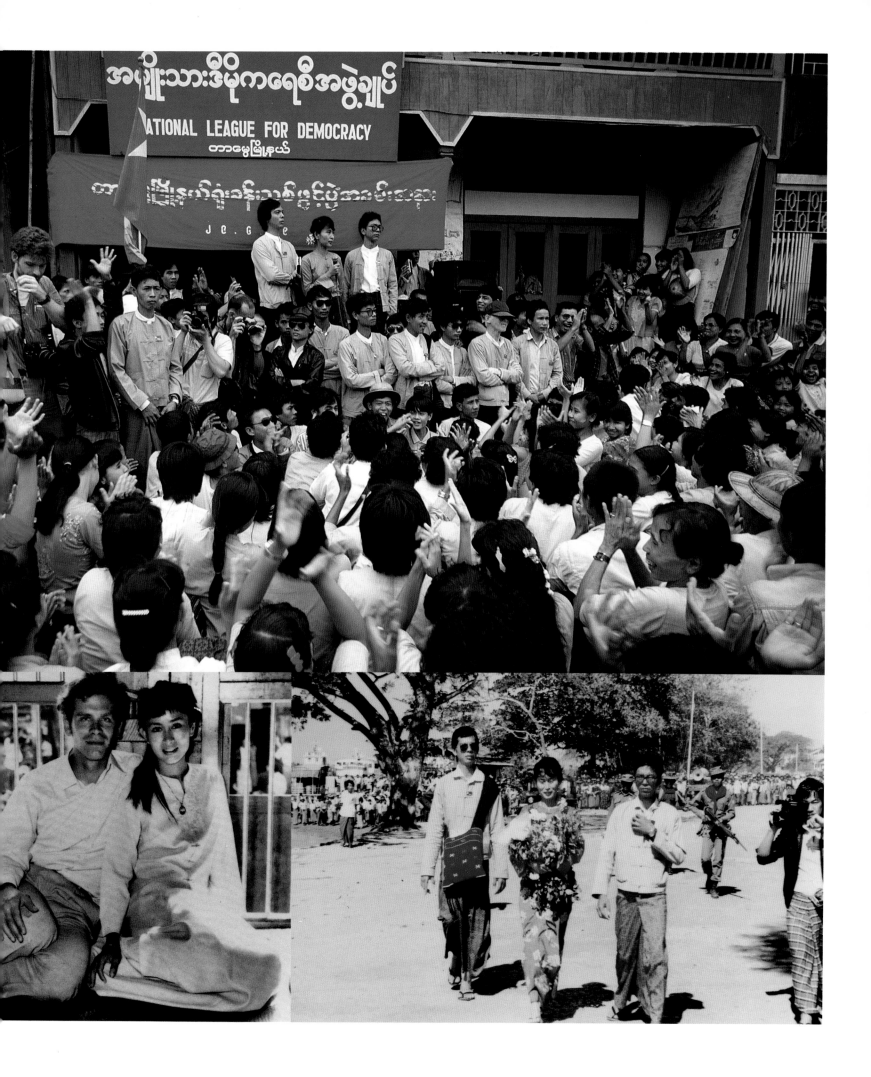

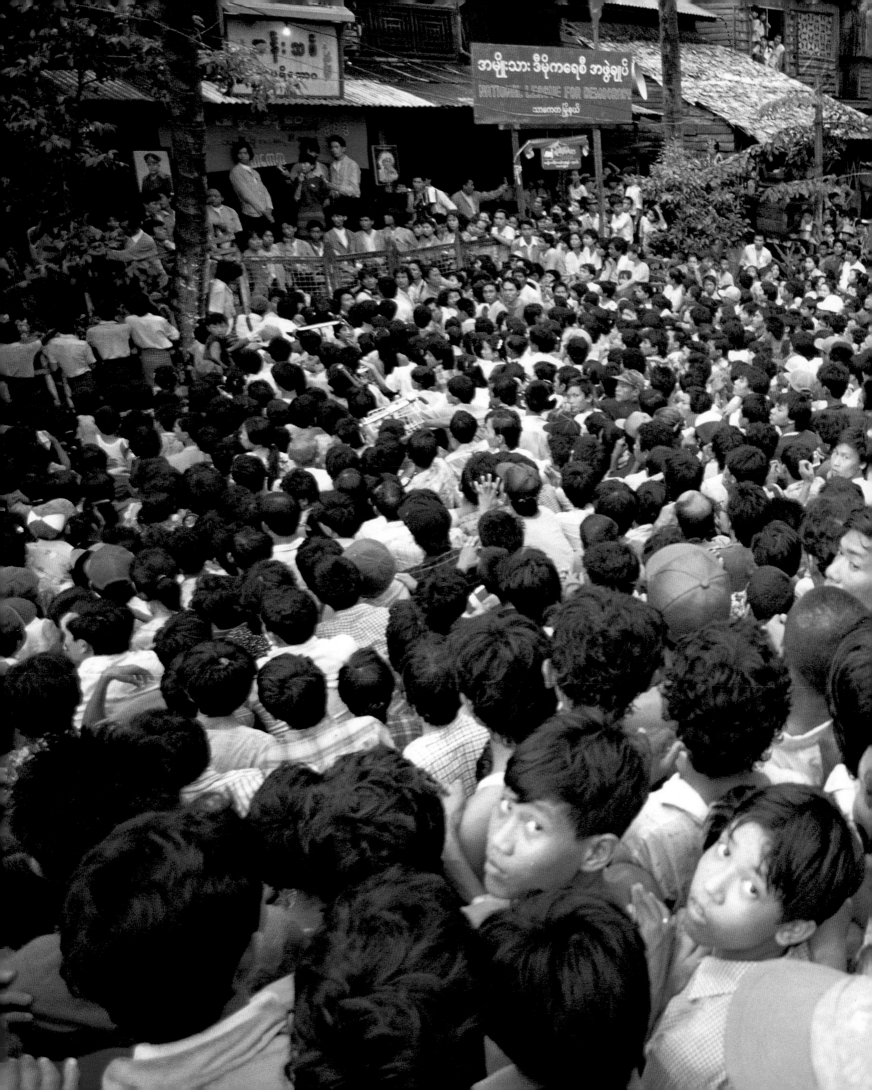

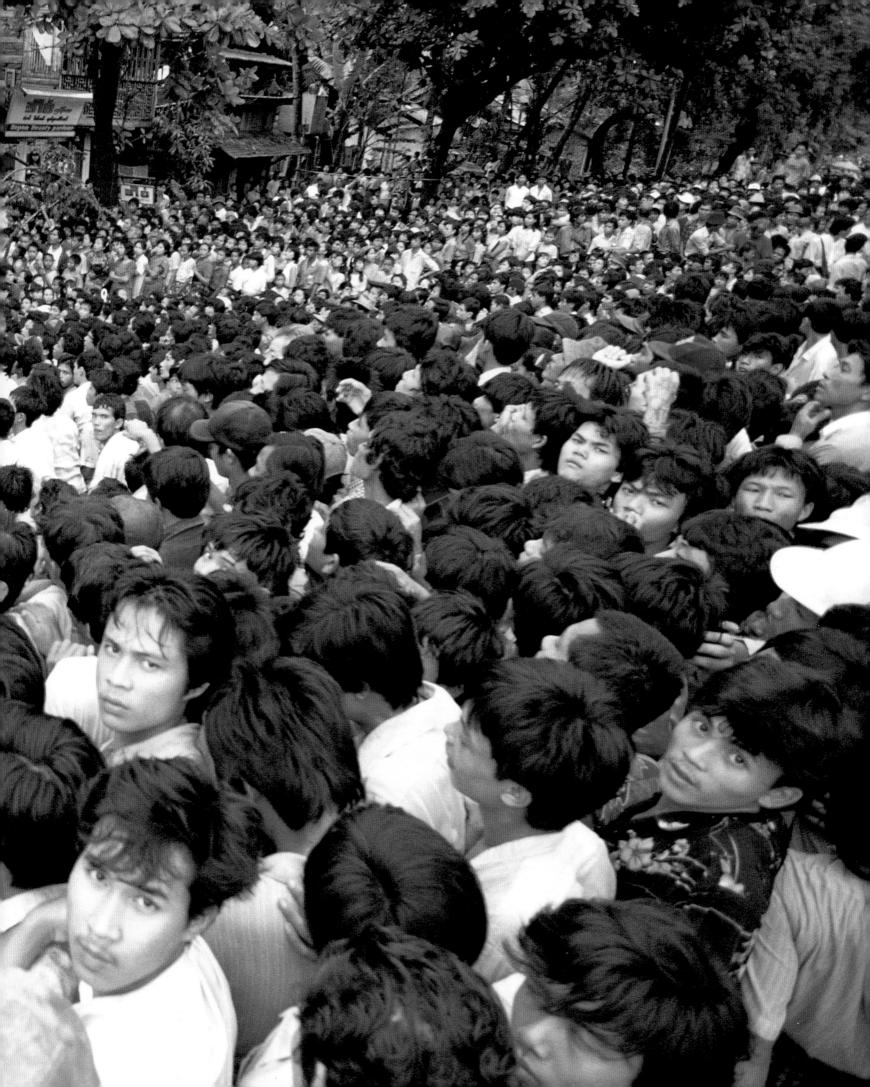

Previous spread: Aung San Suu Kyi further unified and strengthened the nation with her message of nonviolent civil disobedience, self-responsibility, and courageous determination for democracy.

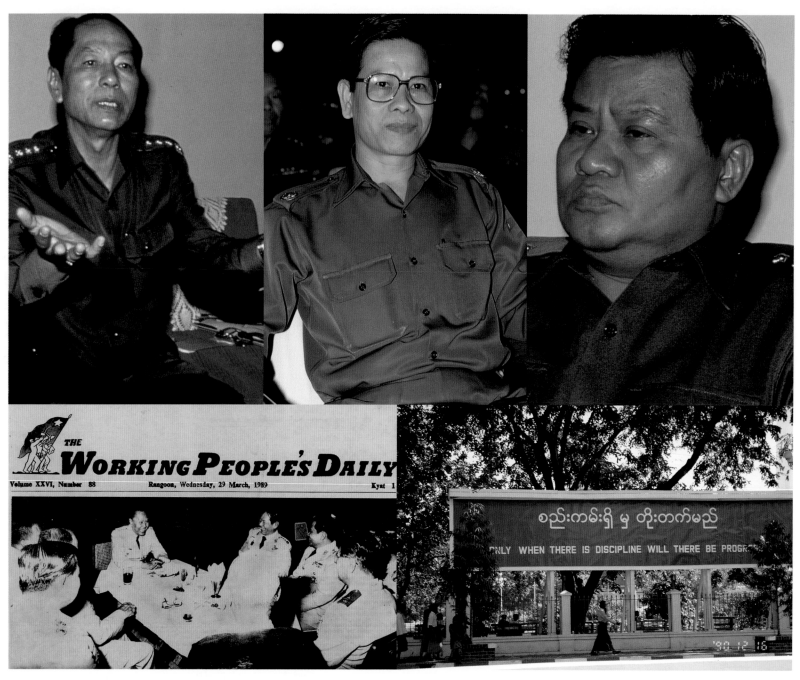

On September 18, 1988, Ne Win had commandeered a staged military coup, setting up the nineteen-member State Law and Order Restoration Council (known by the acronym SLORC) as the ruling body of Burma. General Saw Maung (top left) was appointed chairman of the SLORC. Major General Khin Nyunt (top middle), head of Burma's secret intelligence agency, was also a key player within the SLORC hierarchy. General Than Shwe (top right) eventually replaced Saw Maung as the chairman of the SLORC, when Saw Maung was forcibly retired. Above left: The last known photograph to appear pub-

licly in Burma of the scrupulously private dictator Ne Win (seated center), dressed in full military attire as he celebrates with SLORC leaders. When this front-page photograph was published, the people were outraged to see Ne Win laughing with his SLORC comrades—an unthinkable act of arrogance from the man responsible for the bloodshed and grief the population was attempting to overcome. Above right: One of many propaganda billboards erected by the SLORC throughout all major cities.

However, observers and democratic leaders soon realized that the SLORC's olive branch was simply a mask, as the military viciously harassed supporters of democratic parties. In 1989 and 1990 alone the *New York Times* reported that over 500,000 citizens were forcibly relocated from many major urban centers and herded into disease-ridden "satellite towns." The areas emptied by the SLORC were known to be strongholds of the democracy movement and home to supporters of Aung San Suu Kyi. In addition, many party headquarters were raided by SLORC soldiers.

Despite the SLORC's escalating oppression, Aung San Suu Kyi strengthened her message of nonviolence and deepened her resolve to bring Burma true democracy through dignified means. During this arduous period of struggle she traveled tirelessly to rural areas around the country, urging her devout followers to remain unified and disciplined. She and all who gathered around her risked long prison terms by defying arbitrary government edicts forbidding gatherings of more than four. Wherever Aung San Suu Kyi spoke, occasionally to crowds of hundreds of thousands, the Burmese people remained peaceful as they strengthened in their determination to liberate their country from the shackles of the military regime.

Even under conditions of blatant harassment, the NLD and its leaders continually sought reconciliation with the SLORC. Nevertheless, all attempts at a genuine dialogue went unanswered. Aung San Suu Kyi said in a public speech, boldly directed to leaders of the SLORC, "To resolve problems…we must meet face to face. Why do you not have the courage? Why do you still hold the gun?… [If the leaders of the SLORC are not] willing to engage in dialogue, they are not fit to run a government, not fit to administer the nation…Solving problems by using lethal weapons on unarmed civilians is a fascist method." Eventually, desperate SLORC leaders could no longer tolerate the powerful popular momentum of this campaign for democracy. On July 20, 1989, Aung San Suu Kyi was placed under house arrest for "endangering the state," where she remains to this date. The SLORC has repeatedly made efforts to entice her to permanently leave the country in exchange for her release, but she has consistently refused to abandon Burma by agreeing to the conditions of her captors.

Nevertheless, the May 1990 elections were carried out as promised. Despite the fact that she was still in detention, Aung San Suu Kyi's National League for Democracy Party won 392 of the 485 National Assembly seats, or 60 percent of the vote (the military won only ten seats, or 25 percent of the popular vote). The SLORC was stunned by the dramatic landslide victory of the NLD. In response, they decided not to honor the election results. Following a meeting with the SLORC in Burma, a foreign diplomat reported that a fear of "Nuremberg-type

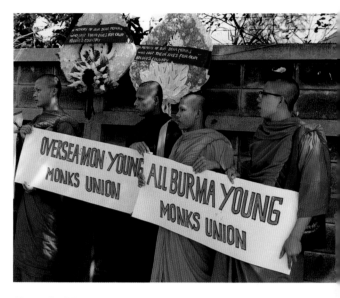

Above: Buddhist monks from all ethnic minorities unified to support the prodemocracy movement. Two of the largest organized groups were the OMYMU (Overseas Mon Young Monks Union) and the ABYMU (All Burma Young Monks Union). Following an SLORC crackdown on monasteries in 1990, monks and nuns organized an unprecedented boycott of religious services to the military. As a result, monasteries were raided; monks were killed, arrested, and forcibly disrobed.

Below: As Aung San Suu Kyi's campaign gathered momentum, truckloads of armed SLORC soldiers were ordered to shadow her. To the right of the army truck, her devout followers formed a protective human shield around her car.

Opposite: Shortly after the military coup, the SLORC announced that they would hold "free and fair" multi-party elections in the spring of 1990. More than two hundred parties registered with the election committee, and campaigning was active although continuously hampered by SLORC harassment. Aung San Suu Kyi's National League for Democracy (NLD) was the strongest and most popular party.

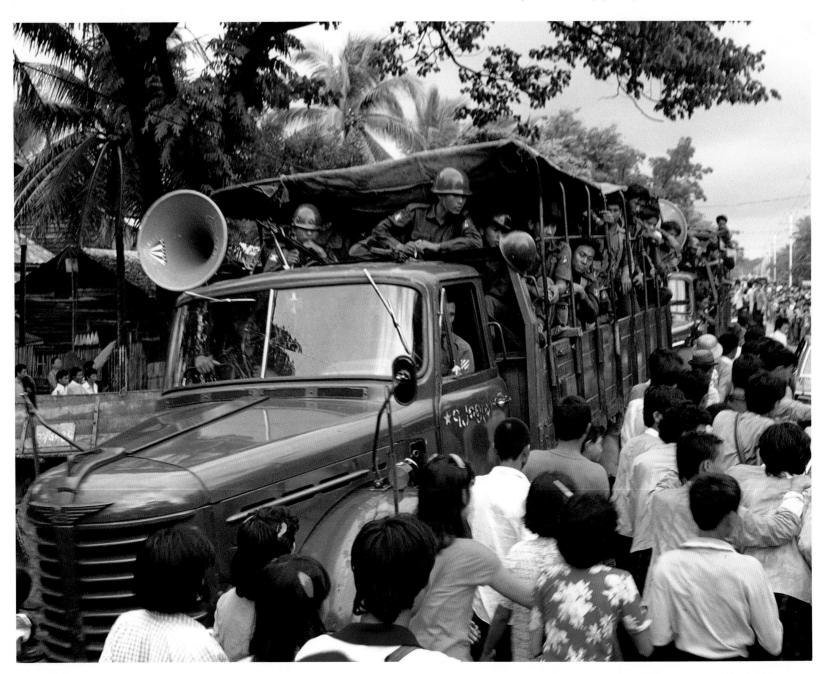

Aung San Suu Kyi traveled throughout Burma for many months, educating her people. With great diginity and gentleness, she began to break down their barriers of fear as she talked to them of democracy and freedom. It was strange that this tiny woman's only weapon was nonviolence. She showed by example that nonviolence truly is the weapon of the strong. Aung San Suu Kyi is a woman who dared. She and her people have persevered and endured enough. Their struggle will soon be over. And a warning must be sent to the SLORC: The free world is watching you!

Betty Williams
Northern Irish peace activist
Nobel Peace laureate, 1976

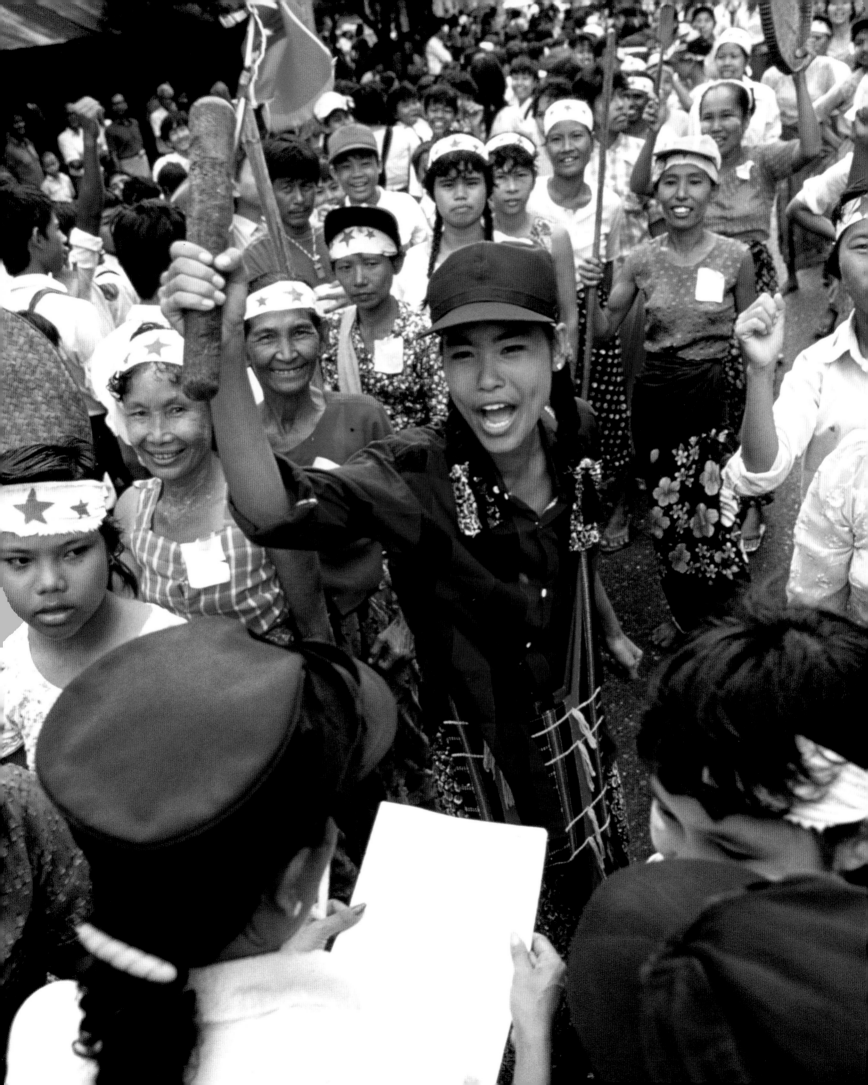

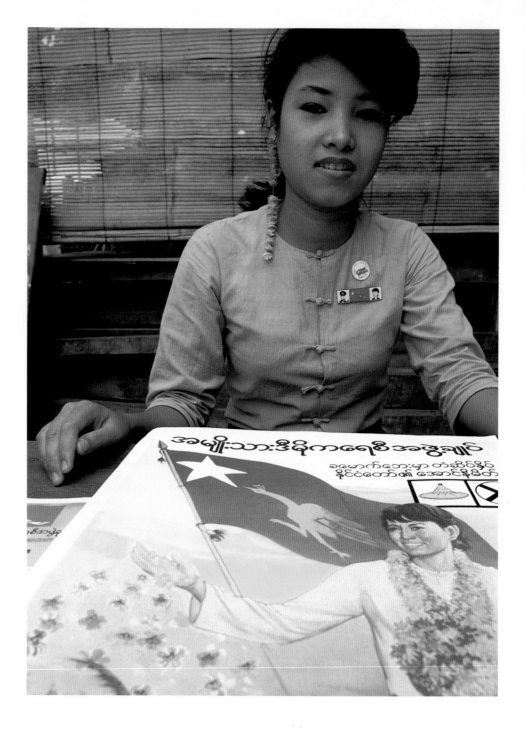

Headlines from the state-controlled
Working People's Daily,
May 30, 1990
(shortly before the SLORC refused to
acknowledge the election results).

On July 20, 1989, Aung San Suu Kyi was placed under
house arrest for "endangering the state." As promised,
the SLORC held the multiparty elections in May 1990
and the National League for Democracy won an over-
whelming victory. Supporters of Aung San Suu Kyi and
the NLD were exuberant over the election results.
However, their joy was short-lived—the SLORC was
not willing to honor the mandate of the people. Instead,
the elected members of parliament were either arrested
(some died or were tortured to death while in prison),
"disappeared," or were forced into hiding. Others fled
from their districts to the remote jungles of Karen State
and joined with the students and ethnic minority leaders
headquartered in Manerplaw.

trials" motivated their refusal to relinquish control. They still have
not turned over authority to these legally elected representatives of
Burma, but instead have arrested the majority of them, some of whom
have died following harsh treatment in prison. Others escaped arrest
by fleeing to primitive encampments along the Thai border, joining
organized groups of students, monks, and ethnic minorities in a
last-ditch attempt to keep Burma's flame of democracy from being
fully and finally extinguished.

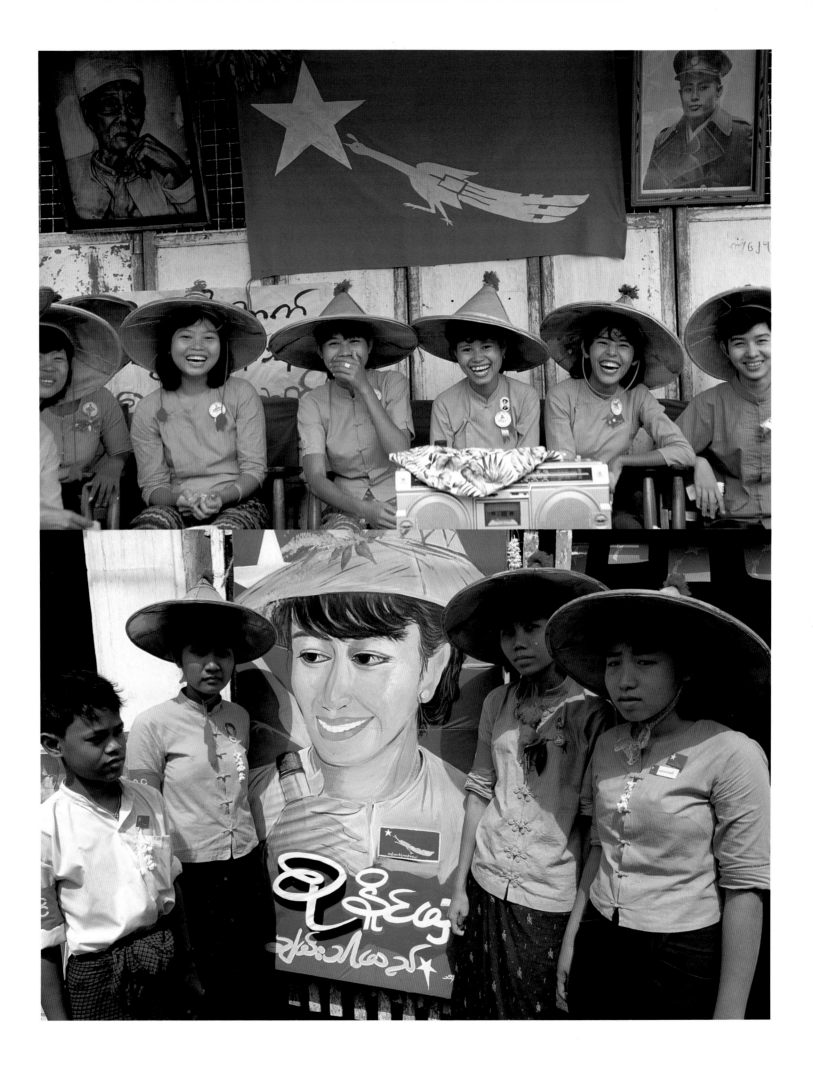

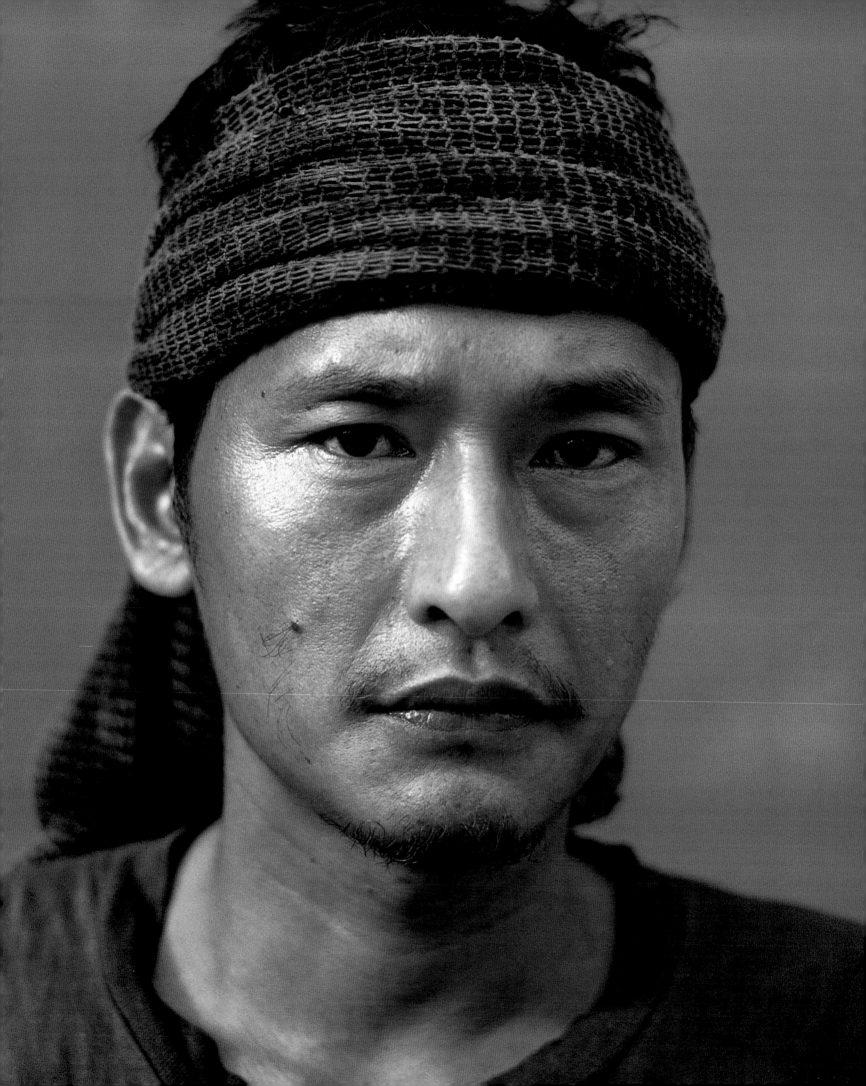

CHAPTER FOUR

DARKNESS IN THE GOLDEN LAND

With Aung San Suu Kyi under house arrest, the results of the "free and fair" elections denied, and the large majority of elected officials silenced, the SLORC leadership wasted no time in further securing their hold on power. Caught in a frenzy of Burman superiority, coupled with a fear of ethnic resistance, the military regime expanded its campaign of terror from the urban centers to the surrounding rural areas, especially to the Kachin, Shan, Mon, Arakan, and Karen states. The SLORC continued to vehemently deny to the world community any involvement in human-rights violations. They repeatedly pronounced their legitimate right to govern Burma, claiming to be the only ones capable of "holding together a disintegrating nation."

In 1991, to better equip the SLORC's 280,000 rank-and-file troops, the military leadership purchased $1.2 billion in military hardware from China, which was seeking to strengthen its ties with its smaller neighbor. These weapons included eleven older Soviet-made jets, about a hundred tanks, dozens of antiaircraft guns, and numerous gunboats, rocket launchers, and assault rifles. Since Burma is a country with no external enemies, it can be deduced that these weapons were being acquired solely for the purpose of waging war against the country's own people.

In early 1991, the SLORC and its army of mostly uneducated adolescents began to ravage the rural areas of Burma with orders from the top to "kill or be killed." Consequently, tens of thousands of refugees poured out of the country into neighboring Thailand, China, and India. Hundreds of thousands were internally displaced, forced to flee the land their families had called home for centuries. It became commonplace that upon encountering minority villages near the frontier with Thailand, SLORC troops would mercilessly burn them to the ground, shooting livestock, killing, and raping. Mines were scattered throughout the countryside, often maiming children who mistook them for toys. During the period of 1988 to 1992, Amnesty International reported that they had located nineteen centers of torture in Burma and that the country had been transformed into a "terror state."

As part of the SLORC's mass relocation campaign, over a hundred thousand ethnic villagers were ordered into fenced enclosures at SLORC army camps under threat of being shot if they remained in their villages. In 1991, eighty thousand Palaung of Shan State were shifted into holding zones; in 1992, twenty thousand Karenni received the same treatment along with thousands of others from Karen and Mon states. From this pool of captured villagers, SLORC selected the most fit to work at forced labor. The official SLORC statement regarding the purpose of the "relocation program" is to "develop key villages where the infrastructure— roads, power, and water supply, housing, etc., will be developed."

The phenomenon of slavery for forced labor in Burma, or porterage, has been extensively documented by Amnesty International, Asia

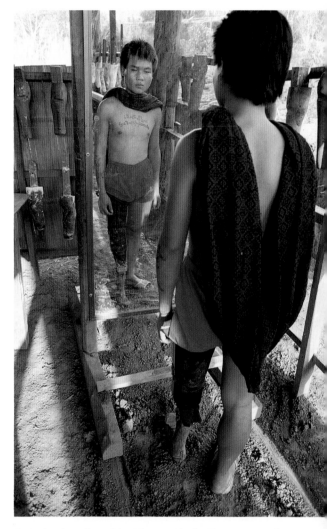

Opposite: As reflected in this portrait, the Burmese people were forced to face a level of brutality they had not known before.

Above: As the SLORC expanded its oppression into rural areas, thousands of ethnic minorities lost arms and legs from mines planted in fields and near villages.

The dark veil of secrecy that shrouds Burma must be lifted before the back of democracy is broken completely.

Alan Cranston, 1991
United States senator

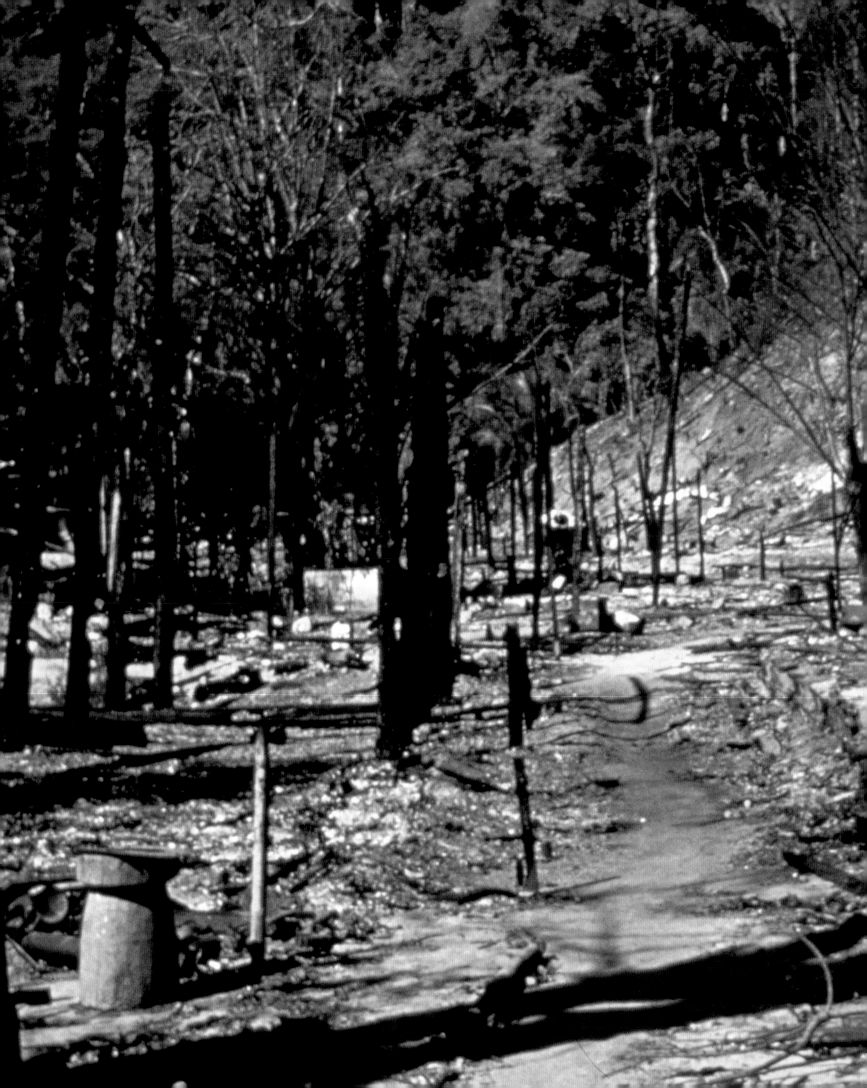

Previous spread: The remains of a typical Karen village after it was burned by SLORC soldiers during their 1991 offensive against ethnic minorities who they claimed were "harboring rebels."

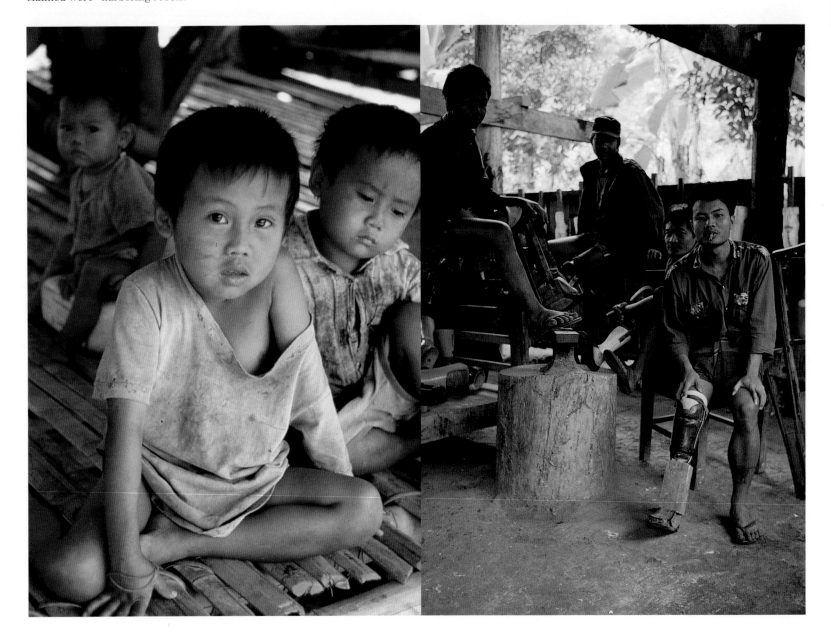

This page and opposite: By mid-1994, over 400,000 refugees had fled Burma into neighboring countries and makeshift camps along the Burmese border. During their journeys, refugees were maimed by land mines, suffered and died from malaria, and were enslaved by SLORC soldiers.

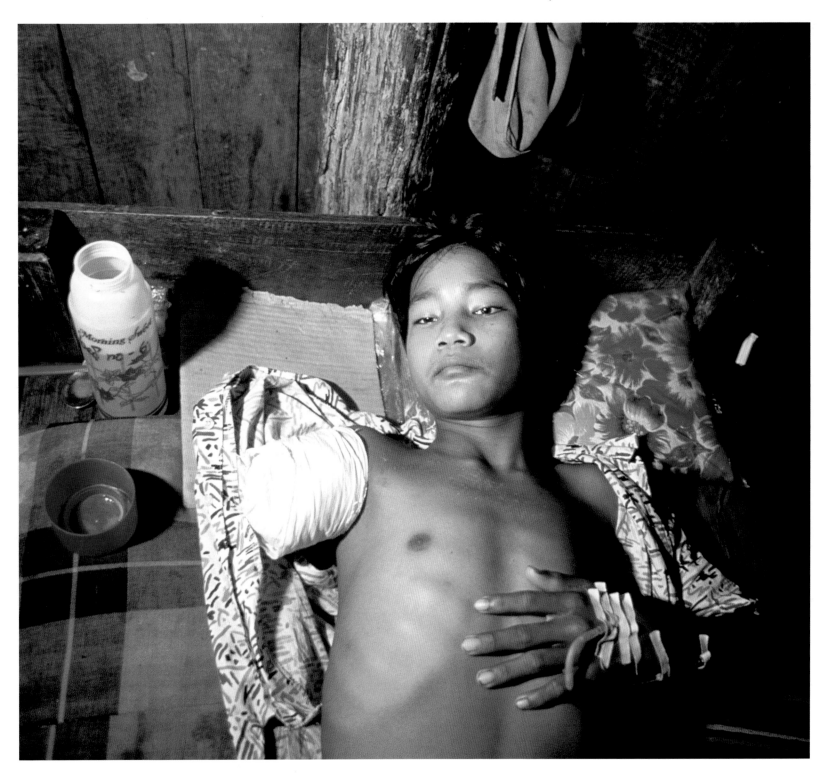

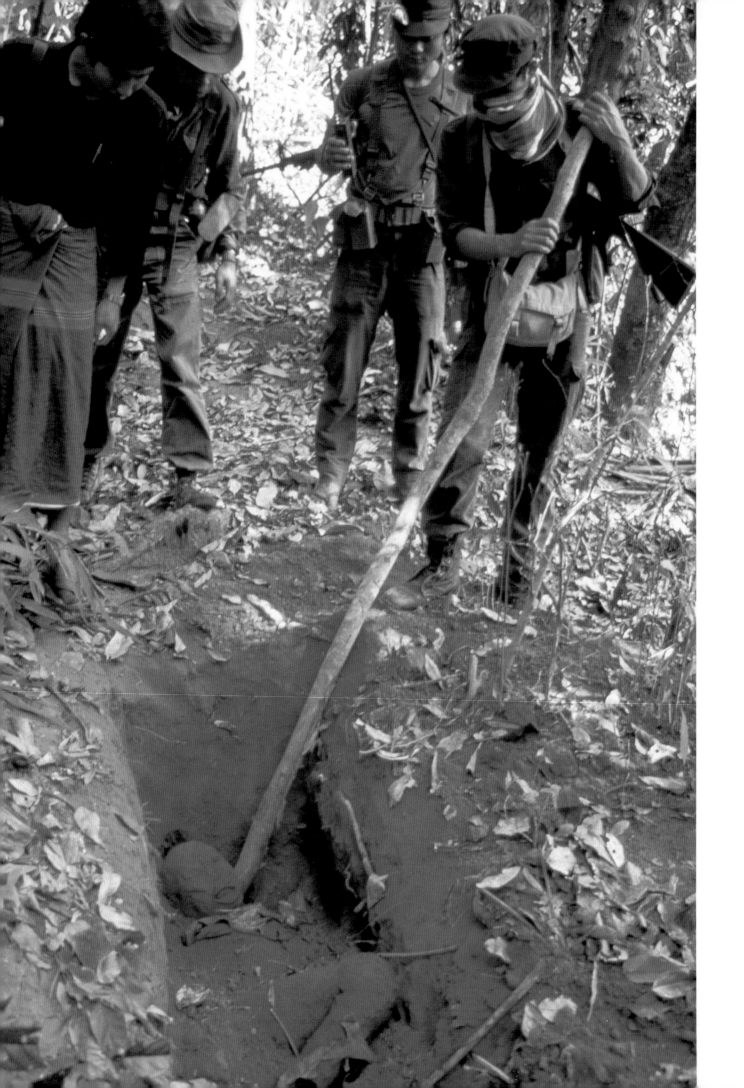

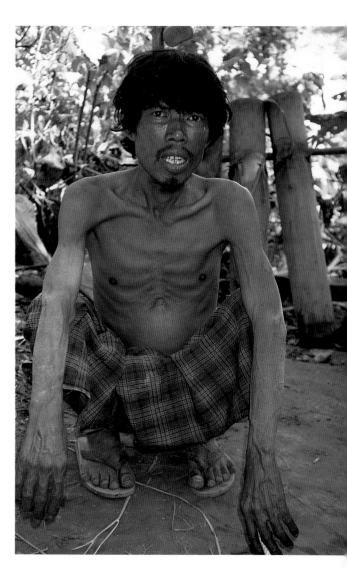

Watch, and the U.S. State Department. Abducting victims from cities and villages alike, these individuals are burdened like animals, carrying heavy supplies and munitions over steep terrain until they collapse. Women porters are repeatedly raped throughout the night. Once the porters become too weak and sick to work, they are left to die along the jungle trail or killed outright by SLORC soldiers.

While the SLORC carried out its numerous campaigns of rural destruction, democratic opposition leaders continued to consolidate and organize at Manerplaw, their remote jungle headquarters along the Moei River, which separates Thailand from Burma. In December 1990, leaders of Burma's ethnic minorities, the All Burma Students Democratic Front (ABSDF), All Burma Young Monks Union (ABYMU), and members of parliament elected the previous May had united under a common banner called the Democratic Alliance of Burma (DAB). They formed the National Coalition Government of the Union of Burma (NCGUB), an interim parallel government headed by Dr. Sein Win. Since then, this "government in exile" has been recognized by the European parliament and has lobbied at the United Nations for the removal of the illegal SLORC's seat in the General Assembly. Prime Minister Dr. Sein Win has traveled extensively throughout the world seeking the end to SLORC control, the honoring of the May 1990 election results, the immediate and unconditional release of Aung San Suu Kyi and other political prisoners, and the restoration of democracy in Burma. In March 1991, eleven United States Senators submitted a resolution to President George Bush urging that the United States initiate economic sanctions against Burma's military government, a resolution that has still not been acted upon.

In late 1991 and early 1992, the SLORC intensified its efforts to drive the Muslim Rohingyas from their homeland of Arakan State in northeast Burma. During the first few months of 1992 more than 225,000 Rohinghas fled into neighboring Bangladesh, recounting stories of mass murder, gang rapes, and village burning. The *Bangkok Post* reported that seven hundred Rohingha youths died of suffocation after SLORC soldiers locked them in a warehouse. Two hundred Muslims at prayer were massacred when SLORC soldiers opened fire inside a mosque.

The Bangladesh government stated in mid-1992 that 264,887 Rohingyas remained in Bangladesh camps, riddled by starvation and disease. Even under these devastating circumstances, most refugees do not feel safe returning to their homeland without the protection of the United Nations. The UN has attempted to oversee a safe return of some refugees, but its efforts have been repeatedly thwarted by the SLORC. Meanwhile, in late 1993, Burma's total refugee count in Thailand, Bangladesh, and other countries reached nearly 400,000.

Above: An escaped Burmese porter—a term used by the United Nations, leaders of democratic governments, and human-rights groups worldwide to describe victims of forced slavery. In 1991 alone approximately twenty thousand such porters died of disease and starvation or were killed by their captors when they became too weak to carry their loads.

Opposite: One of the numerous shallow graves that has been found in the jungles of Karen State containing the bodies of porters, often with visible signs of torture. Other bodies were found floating in the Moei River.

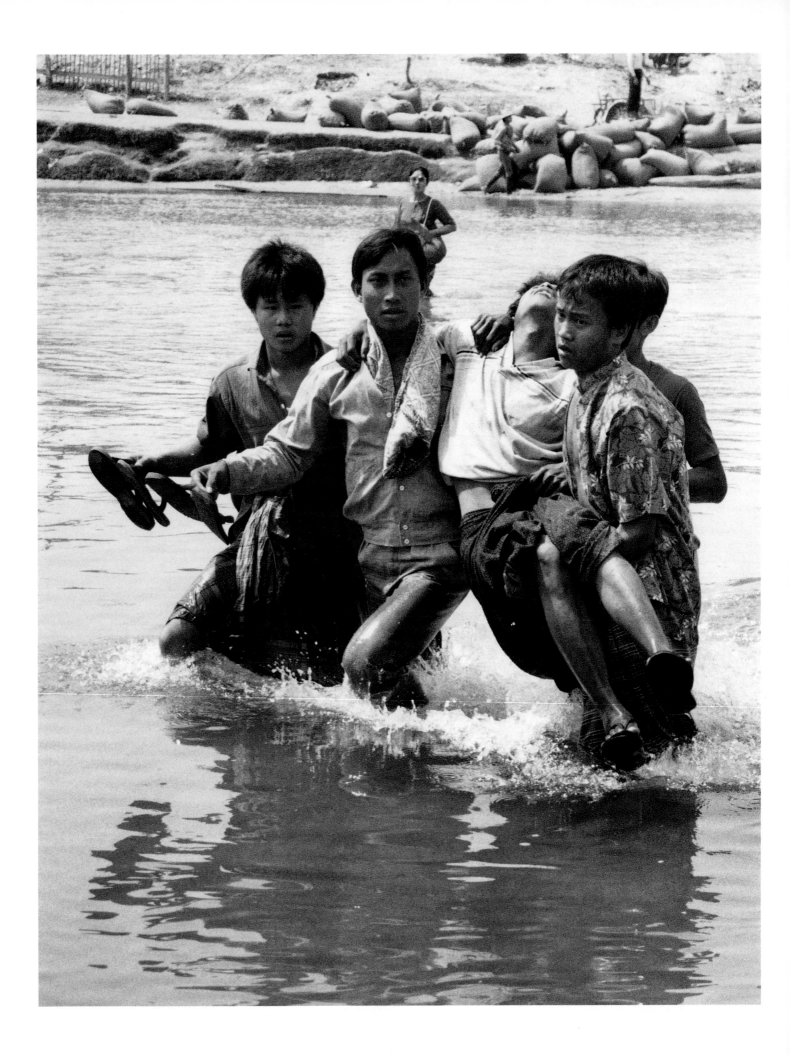

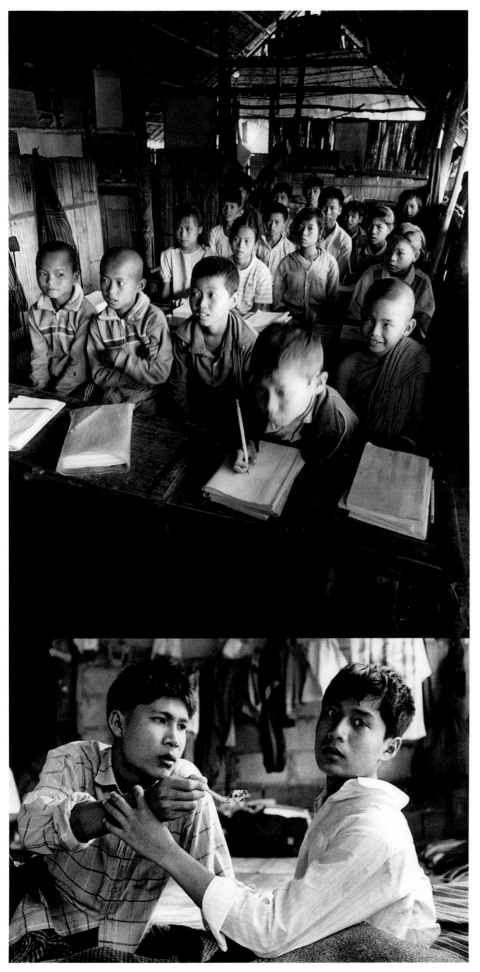

Within a system which denies the existence of basic human rights, fear tends to be the order of the day.... A most insidious form of fear is that which masquerades as common sense or even wisdom, condemning as foolish, reckless, insignificant, or futile the small, daily acts of courage which help to preserve man's self-respect and inherent human dignity.

Aung San Suu Kyi
Nobel Peace laureate, 1991

Opposite: Fleeing persecution by government soldiers, Burmese students carry a wounded comrade across the Moei River into Thailand.

Above left: Schools were set up in refugee camps to give the children some opportunity to continue their normal life. Left: A friend of a severly depressed patient tries to feed him at Dr. Cynthia's Clinic in Thailand. The boy had not spoken for days. The clinic serves the medical needs of Burmese who have fled Burma to escape repression by the Burmese government.

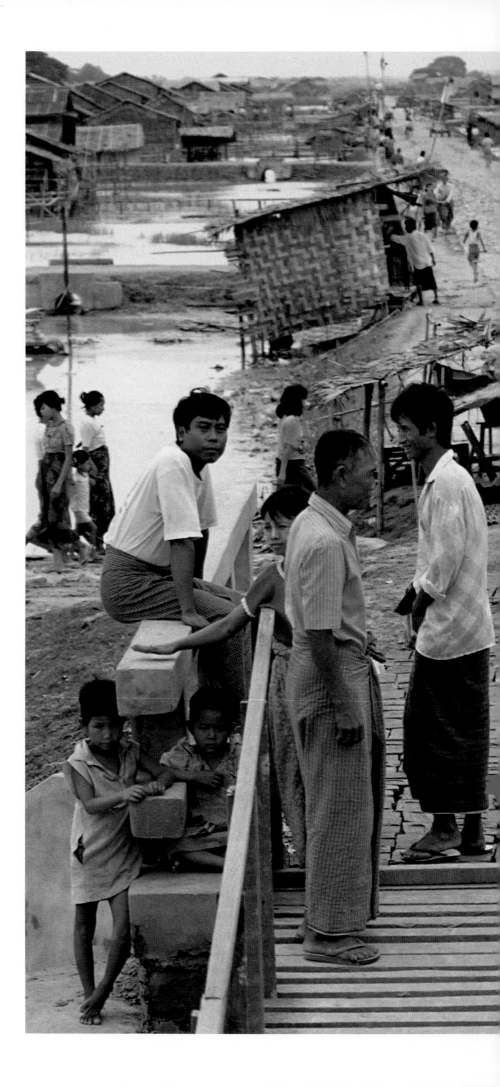

"At least 500,000 Burmese are being forced to move from cities to new, ill-prepared outlying towns where malaria and hepatitis are rampant. Diplomats described seeing Burmese families sitting along the roadsides by their demolished houses with all their belongings, waiting for up to three weeks for army trucks to take them to relocation sites. The diplomats, who were interviewed by telephone or in Bangkok, said the relocations have been taking place in most major cities."

"Burma: 'Horror Story' of Mass Relocations,"
New York Times, March 20, 1990

The "satellite village" of Hlaingthayar, one of the SLORC's numerous relocation camps. Initially, relocations were forced on people living in areas of strong support for Aung San Suu Kyi and the democracy movement. Presently, 80 percent of Burma's citizens live in poverty. Medicines and hospital supplies are scarce. In a shocking reversal of Burma's former status as "the Rice Bowl of Asia," hunger threatens people in rural areas. Although Burma's ruling military elite live in luxury through immense profits pocketed from foreign exports, the average annual income (as of November 1993) stands at $250 per person.

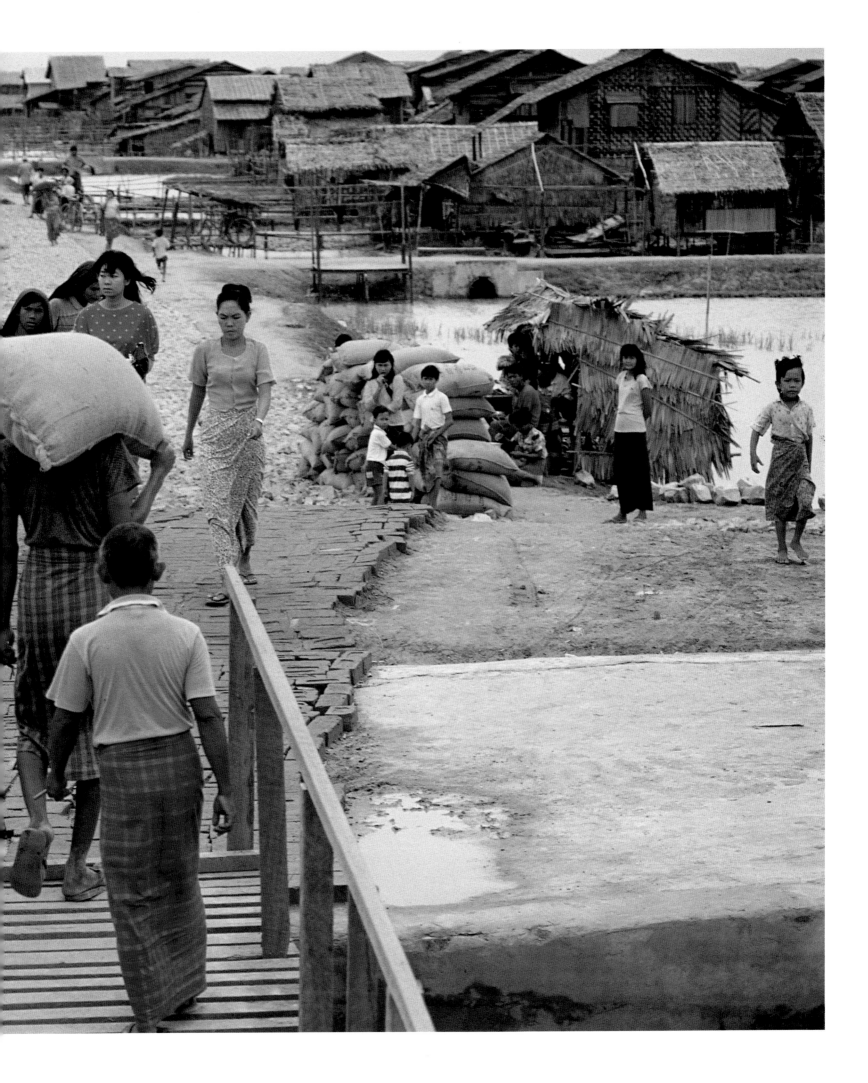

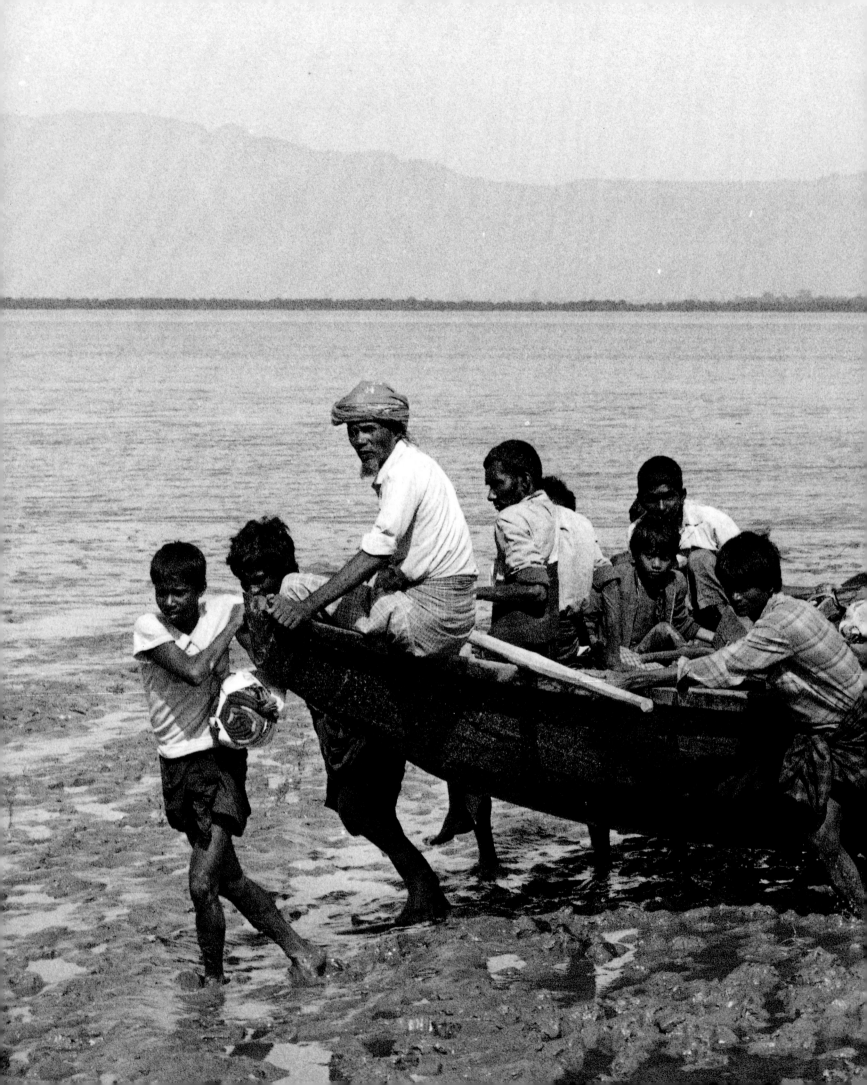

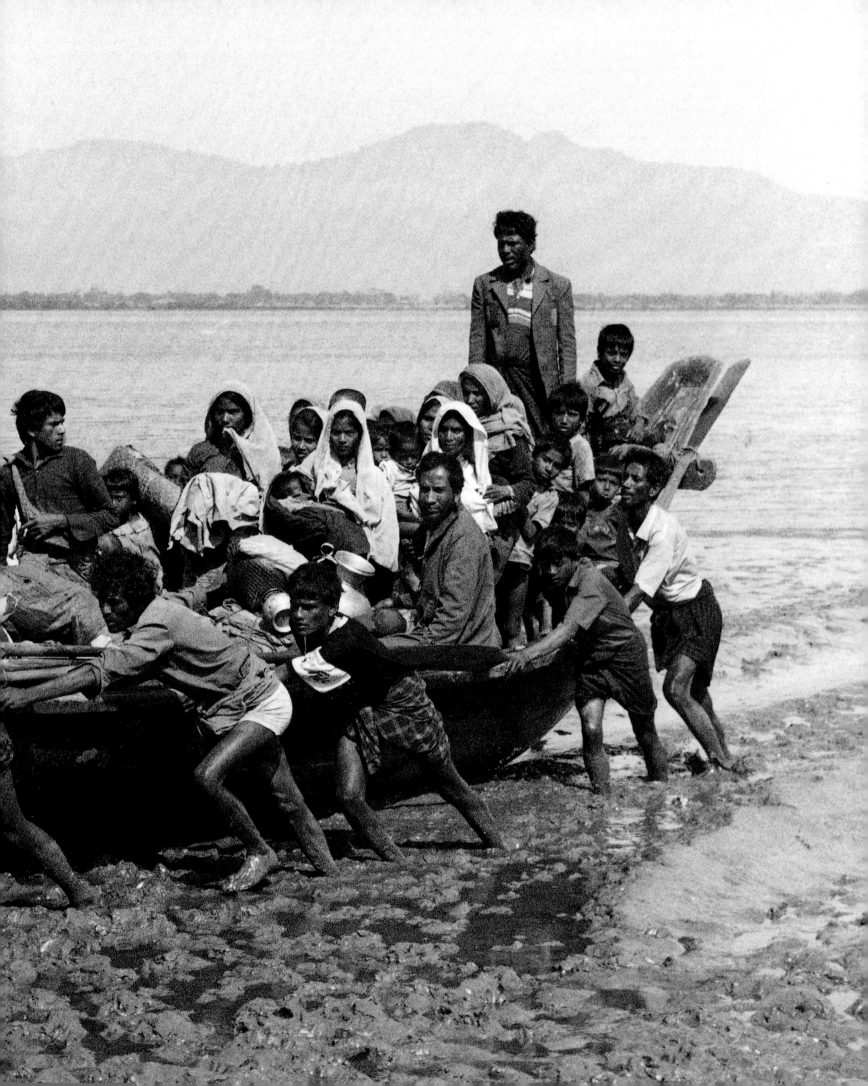

Previous spread: In February 1992, Rohingya, or Burmese Muslim, refugee men pushed a boat through knee-deep mud in the Naaf River near the shore of Naikondia, Bangladesh. They then carried women and children to the dry shore along with their few belongings. Over 200,000 Rohingya refugees fled Arakan State in this fashion in 1992 due to a brutal campaign launched against them by the SLORC in which they were labeled "foreigners."

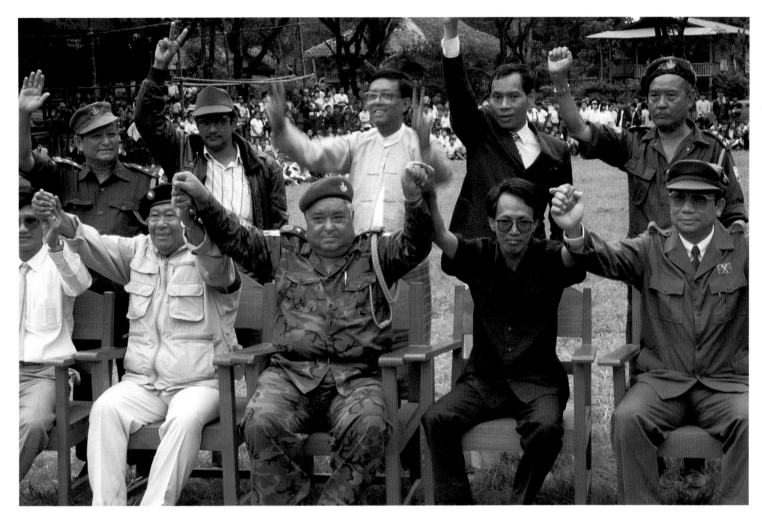

Opposite: Political prisoners chained at the feet work on a road gang. This rare photograph was taken in the remote hills of Shan State near Burma's border with China in late 1993. Hundreds of prisoners of conscience remain in Burma and work at forced labor as the SLORC expands its business opportunities into rural areas.

Above: On December 19, 1990, all ethnic minorities united to form a historic common alliance for one purpose: to bring democracy to Burma. The National Coalition Government of the Union of Burma (NCGUB) was formed under the leadership of Prime Minister Dr. Sein Win, Aung San Suu Kyi's first cousin. Seated second from right, he is flanked by Karen leader General Bo Mya to his left and Kachin leader Brang Seng, right; additional cabinet members and ethnic-minority leaders raise a victory salute.

IN DEFENSE OF DEMOCRACY

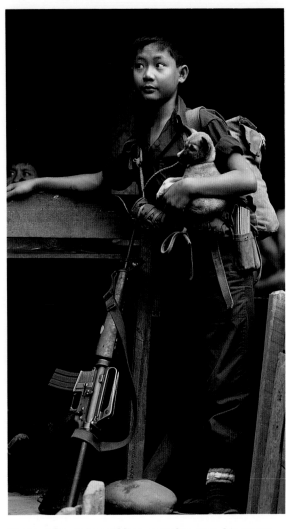

Above: A Karen boy soldier wanted to carry his puppy to the front lines, where he was headed to help counter an SLORC attack.

Opposite: Some children have lost parents in the Karen struggle to resist the SLORC. They have witnessed the horrors of destroyed villages, murder, and forced portering. Many have been thus compelled to take up arms out of desperation.

The SLORC was infuriated by the formation of the NCGUB, headquartered in Manerplaw, which also served as the headquarters of the Karen Liberation Army, the main force that had protected, housed, and fed the Burmese students who had fled after the 1988 massacres. As the democratic alliances continued to seek international support and recognition, the SLORC prepared a renewed offensive. Soon after the formation of the parallel government, the SLORC announced Operation Dragon King in 1991, with the intention to annihilate Manerplaw and "destroy these subversive [democratic] elements." Brandishing their newly acquired supply of sophisticated weapons from China, SLORC leadership in Rangoon deployed tens of thousands of soldiers to the Karen State.

Although the Karens and other ethnic groups had been struggling for autonomy from the Burman government for forty years, never before had there been a need for a defense at this level. Women, children as young as twelve, and students from Rangoon joined with the more seasoned Karens to form "armies" equipped with the most minimal supplies and training. Children felt compelled to protect their villages from the onslaught of marauding SLORC infantry, who burned their homes and enslaved, raped, or killed their parents. As the weeks of the jungle offensive continued, the SLORC soldiers escalated their destruction.

The SLORC's attempt to liquidate the Karens and destroy the democratic forces was largely unreported to the outside world. Makeshift jungle "hospitals" were ill equipped to deal with the wounded. During this period, many captured SLORC soldiers admitted that they were forced to swallow or inject a chemically treated amphetamine-morphine-based substance before they entered front-line combat. The effect produced a type of psychotic rage that also rendered them numb from pain. Even injured SLORC soldiers took hours to come down from their altered states before the pain of their wounds was felt.

In 1992, at the end of a second dry-season offensive, the SLORC came very close to capturing Manerplaw; against all odds, the Karen-led democratic forces managed to repel the SLORC soldiers and preserve their headquarters, essential to the continuity of Burma's democracy movement and the preservation of the Karen culture.

While many minorities were under attack, the SLORC constructed dubious cease-fire agreements with a select number of ethnic hill tribes, mostly in the Shan State. These remote tribes had been at war with the Rangoon government for years in order to assure their continuing control of Burma's flourishing opium trade in the famed Golden Triangle. Therefore, many heralded the cease-fire as good news, until the SLORC's true motive was revealed. Since the SLORC

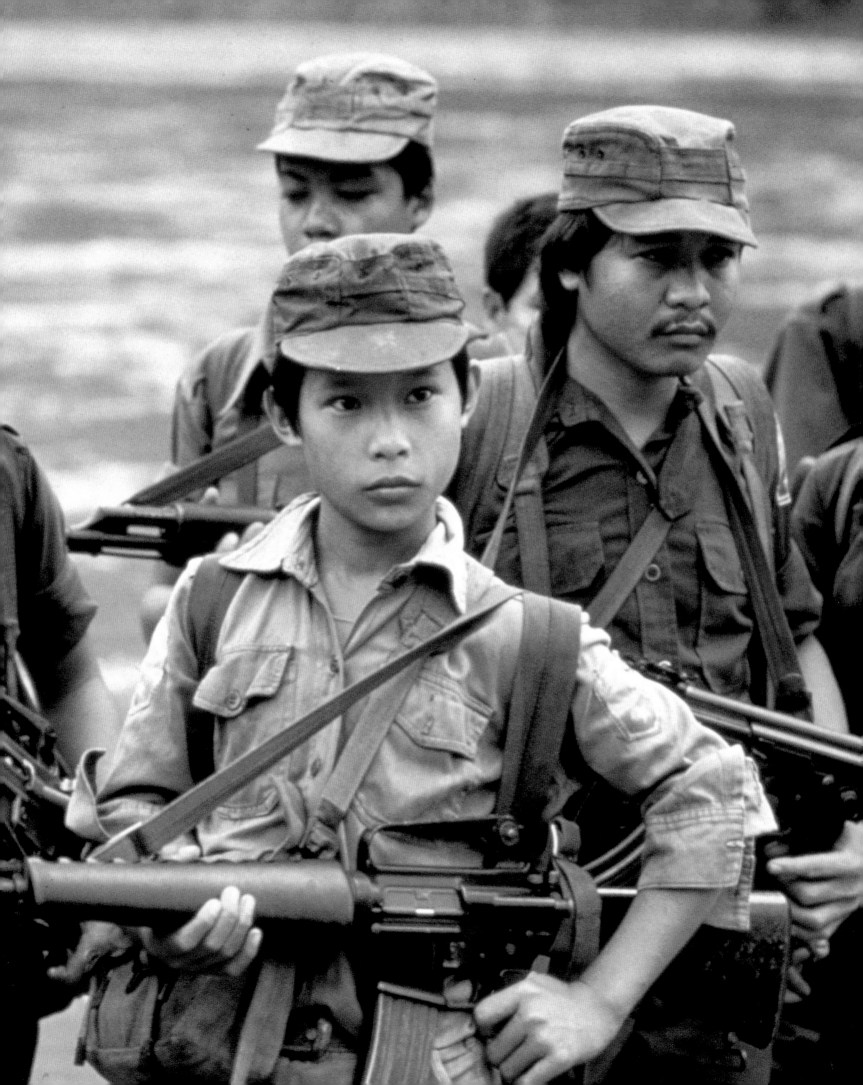

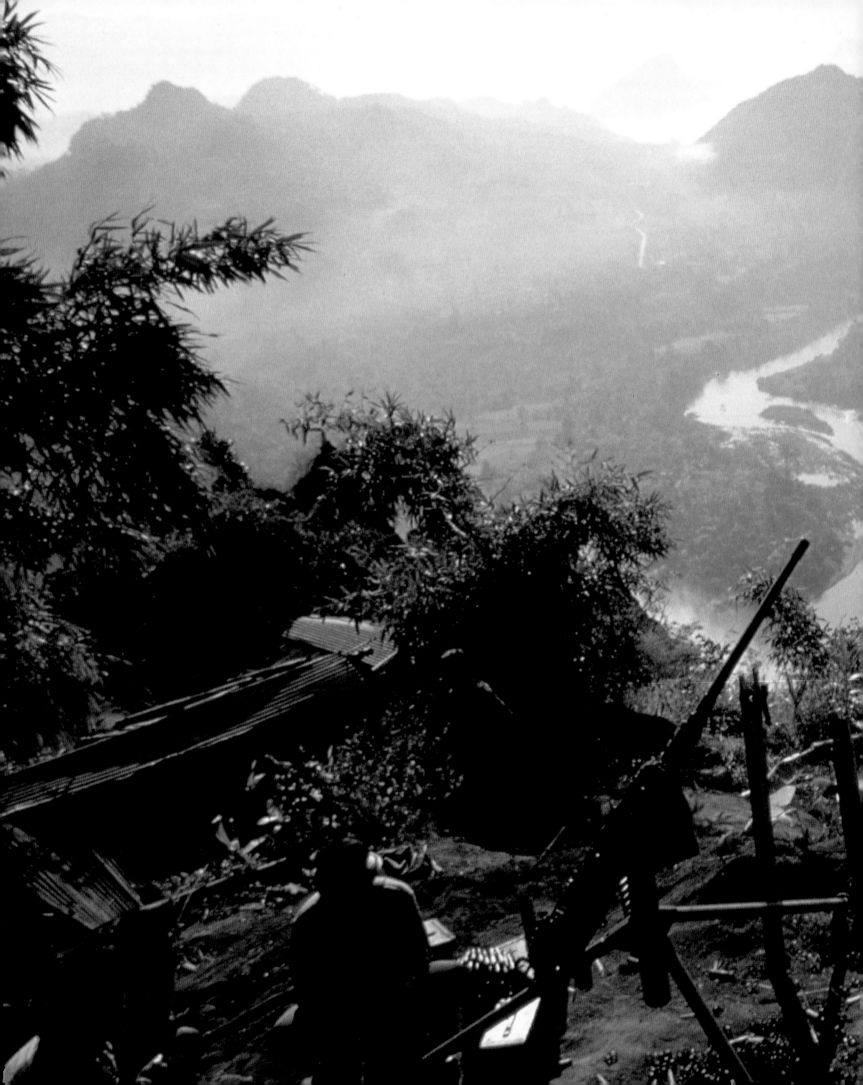

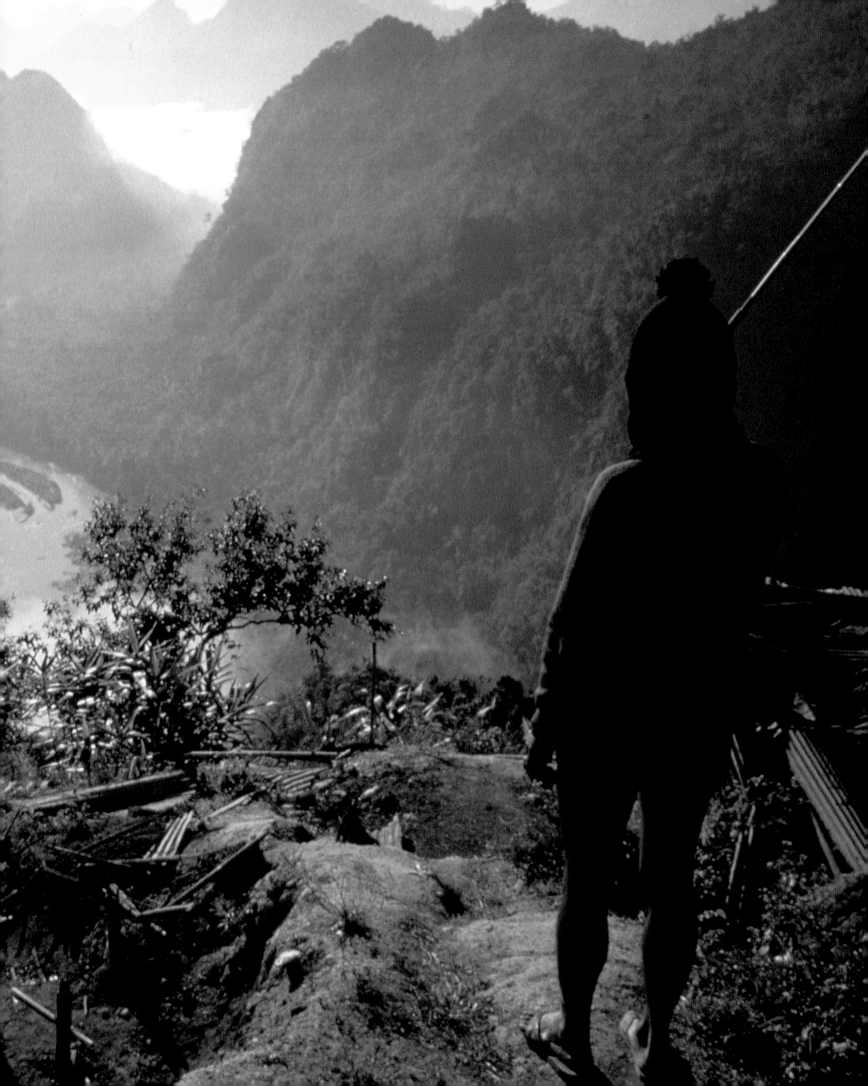

Previous spread: Karen machine-gun position overlooking
Manerplaw—the remote jungle headquarters of the
democratic forces—in Karen State along the Moei River.
To the left of the river is Thailand, to the right is Burma.

Below: An eleven-year-old Karen boy prepares for combat.

Opposite top: Women trained to join the forces defending
Karen State from the onslaught of SLORC troops.
Opposite bottom: The democratic forces, desperate for
aid from the outside world, often used the most primitive
weapons to defend themselves. The SLORC was
equipped with $1.2 billion of weapons from China.

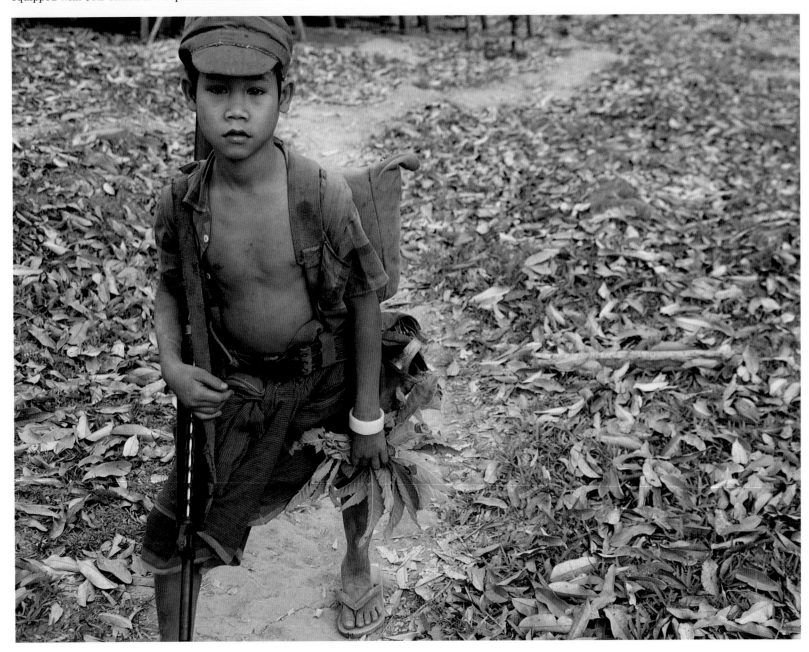

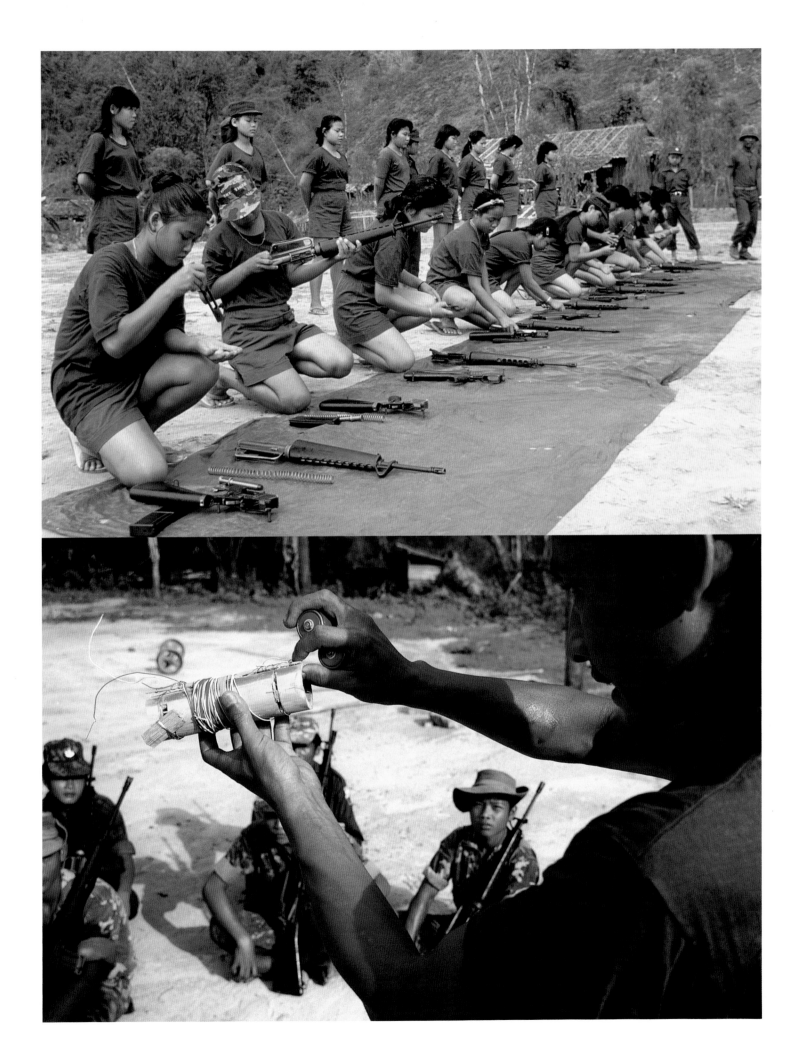

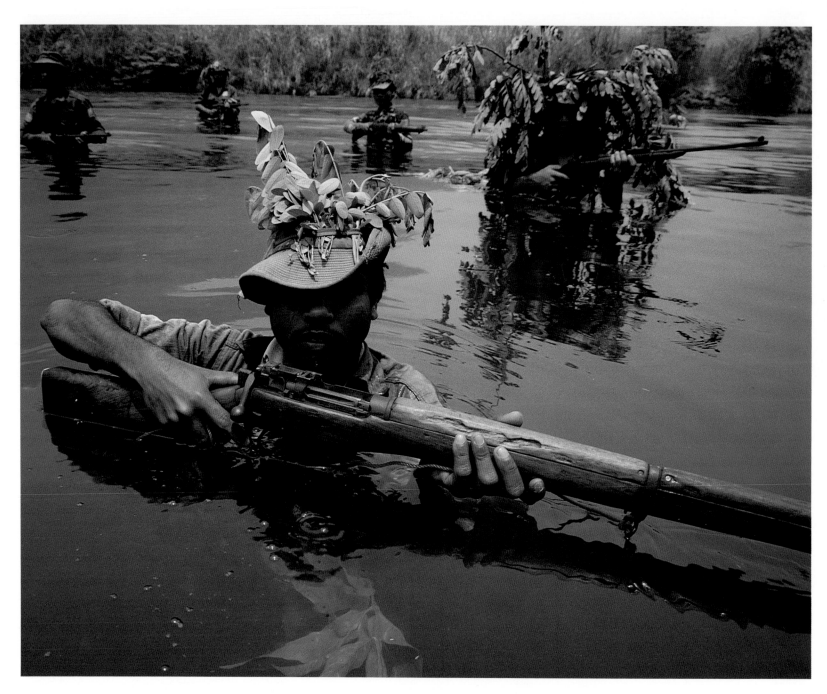

Above: Karen soldiers perform military exercises in preparation for Operation Dragon King, the SLORC's offensive of 1991.

Opposite: A troop of Karen soldiers heading out of Manerplaw en route to the Mae Paw ridge line to face the approaching twenty thousand SLORC troops in January 1991.

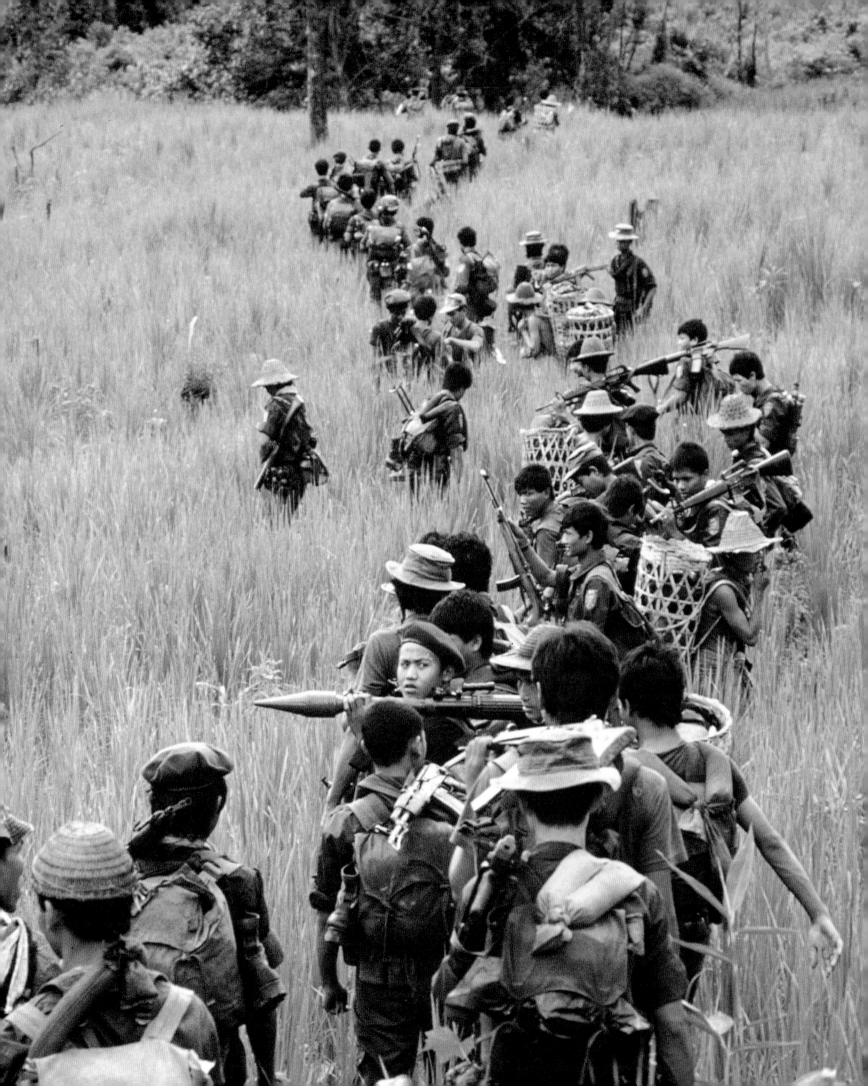

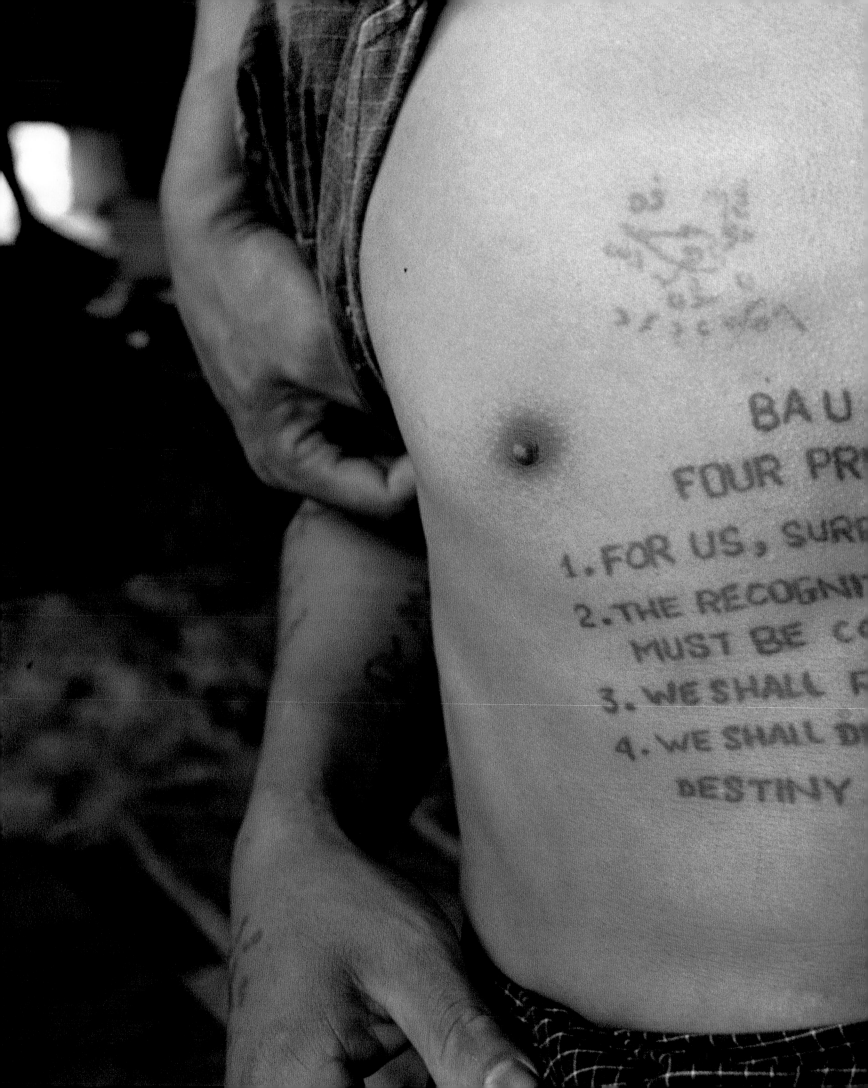

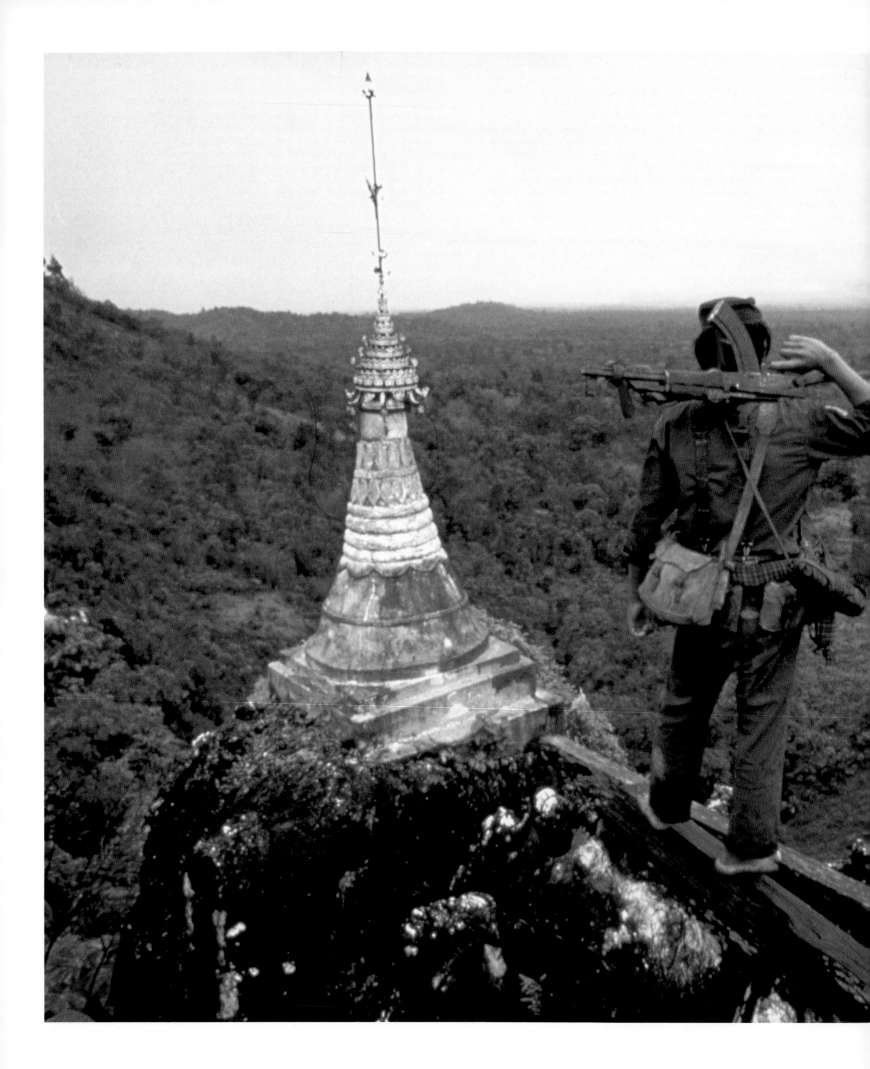

took power, Burma's heroin production has doubled, providing the SLORC with a new and lucrative source of income.

On April 7, 1992, the United States Senate and Congress issued a terse concurrent resolution which made this point clear: "…since 1989, the SLORC has provided both military and economic support to drug-trafficking groups and allows them to produce and trade illicit drugs at their will; …the majority of all opium and heroin produced in Burma is exported to the United States… [which has] contributed to or directly caused the death of thousands of Americans, especially young people and the urban poor; …the SLORC military regime used proceeds from the sale of illegal narcotics to purchase $1.2 billion of arms in 1991 from the People's Republic of China." The United States Drug Enforcement Agency reports that Burma supplies nearly 75 percent of the heroin sold on city streets in America; 60 percent of the world's supply originates in Burma. No longer the world's leading exporter of rice, SLORC-controlled Burma now defiantly stands as the world's largest exporter of heroin.

Sadly, both Rangoon and Mandalay also face heroin epidemics and an escalating AIDS crisis. Heroin is readily available and easy to purchase in the military, in tea shops, and on university campuses, even though the latter locations are heavily policed for dissidents. Students have reported that military police are actually cooperating in the distribution of this heroin, indirectly promoting heroin addiction as a tool to undermine the student democracy movement. A tragic and ironic twist to the story is that the name "freedom from fear" has been used for the heroin—the name of Aung San Suu Kyi's most famous essay, written to inspire her people. Students suggest that this name was coined and spread by SLORC agents as an enticement for them to escape from the pain of their oppression, and also to belittle Aung San Suu Kyi's message of courage and self-respect.

Even though revenues from the drug trade have been high, the SLORC has still been desperate to increase its capital reserves in order to prevent the nation's economic collapse. Shortly after the coup, the SLORC leaders began a fervent international campaign for foreign investments. Companies from around the world, led by petroleum corporations from the U.S., Canada, and Japan, took the risk to explore for oil and gas at the invitation of the Burmese junta. Among Burma's Southeast Asian neighbors, the Thais became the largest investors. The SLORC opened Burma's abundant natural resources to exploitation, mostly for fish, oil. gas, and minerals, and arranged several multimillion-dollar lumber and logging concessions with Thai and Chinese investors.

By January 1993, Burma had the third-highest rate of global deforestation

Previous spread: Karen and Kachin fighters vigorously
defended their territory, although they were outnum-
bered almost ten to one by SLORC troops.

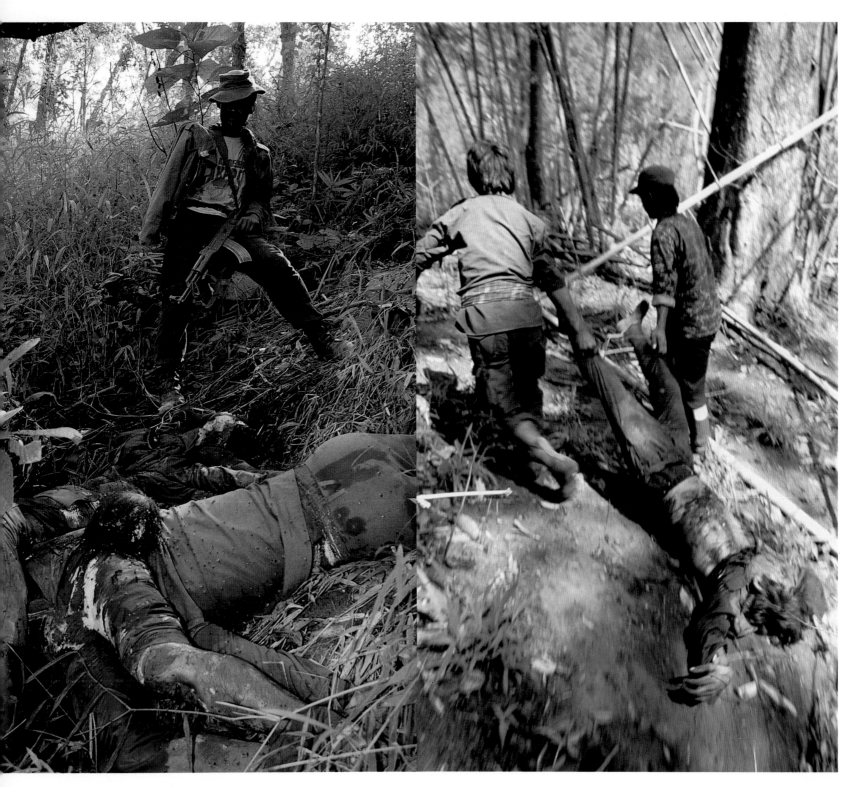

Above: During the height of the 1991 SLORC offensive
to capture the democratic headquarters at Manerplaw,
both sides suffered heavy casualties.

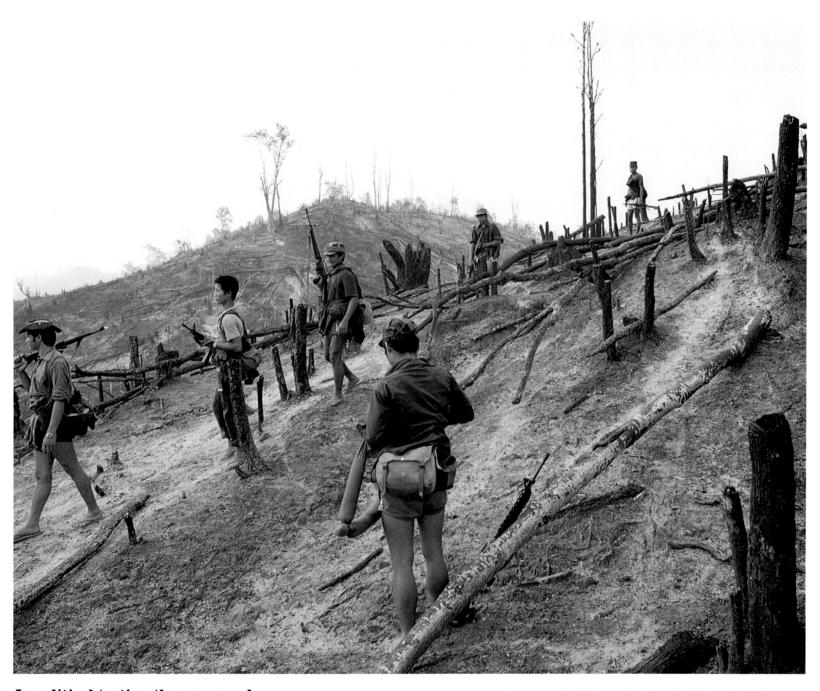

In political tactics, there are such things as dialogue and so forth, but in our military science there is no such thing as dialogue. Someone might say, "Look friend, please do not shoot." Well that is not the way it works.

General Saw Maung, SLORC Chairman
Bangkok Post, November 13, 1990

Above: Following the burning of the land by the SLORC, a Karen group surveyed the charred countryside. SLORC's tactic of burning villages and land became known as its "scorched-earth policy."

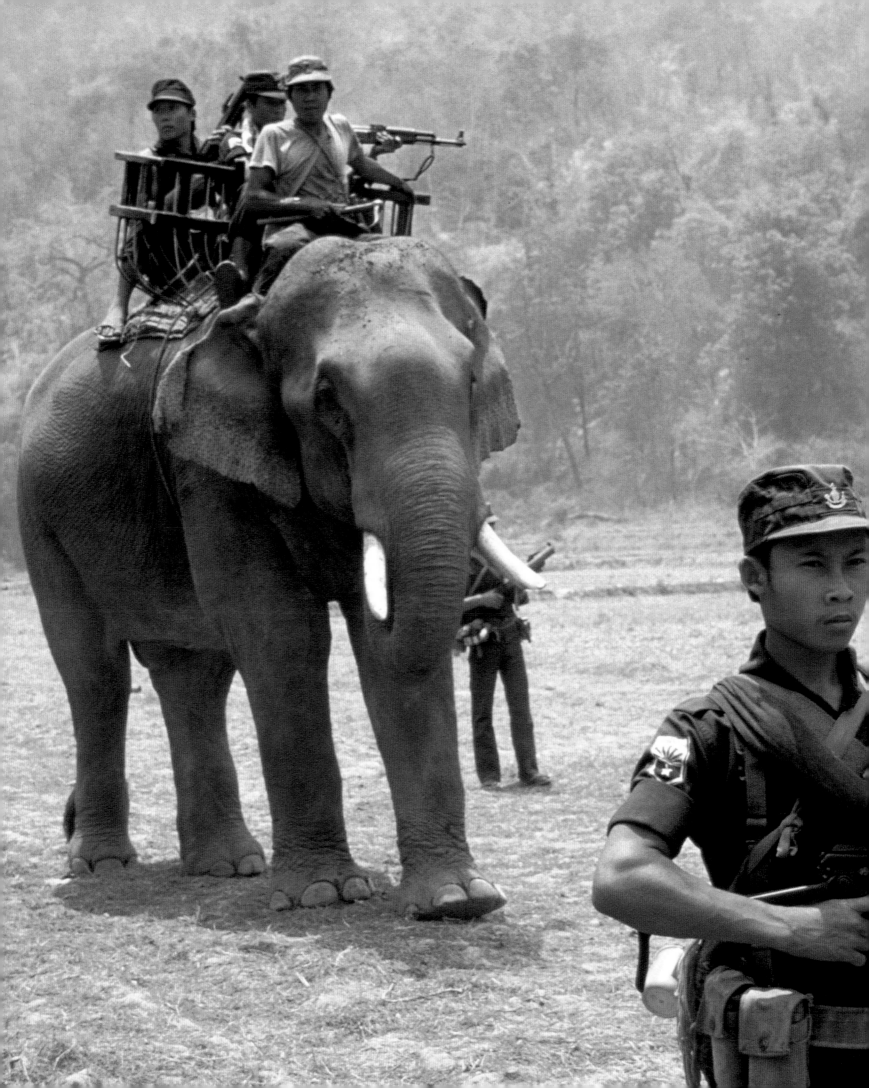

in the world, finishing only behind Brazil and Indonesia. The United
Nations Development Program reported that an area the size of El
Salvador is being cleared each year. Experts predict that the country
could be denuded within ten years, despite the regime's limited plans
for reforestation.

Late in 1993 SLORC signed a $300 million deal with Total Oil
Company of France in part ownership with Texaco, creating an
environmentally questionable plan to develop a natural-gas pipeline
from the Gulf of Martaban extending across the southern border
into Thailand. There are numerous other projects under way with
dangerous implications for a fragile ecosystem that has sustained
many of Burma's ethnic minorities for centuries. They include the
damming of major rivers and the building of large bridges and rural
highways. Some environmentalists believe that the SLORC is one of
the most myopic and ecologically destructive regimes in the world.

Senator Paul Simon from Illinois, a senior member of the Senate
Foreign Relations Committee, commented on the situation as follows:
"We have not done enough to isolate Burma, and we have not sent
the SLORC a clear and consistent message of disapproval. The United
States and the world community need to do far more. Drug proliferation
is one of the new threats that deserves to be treated as seriously as
Russian missiles or international terrorism, but isn't... And the SLORC
is a gang of environmental bandits: Burmese teak forests are being
decimated by unlimited logging, and rivers, water systems, and fisheries
are polluted with no thought of how this will affect the local ecology....
International action is necessary and urgent."

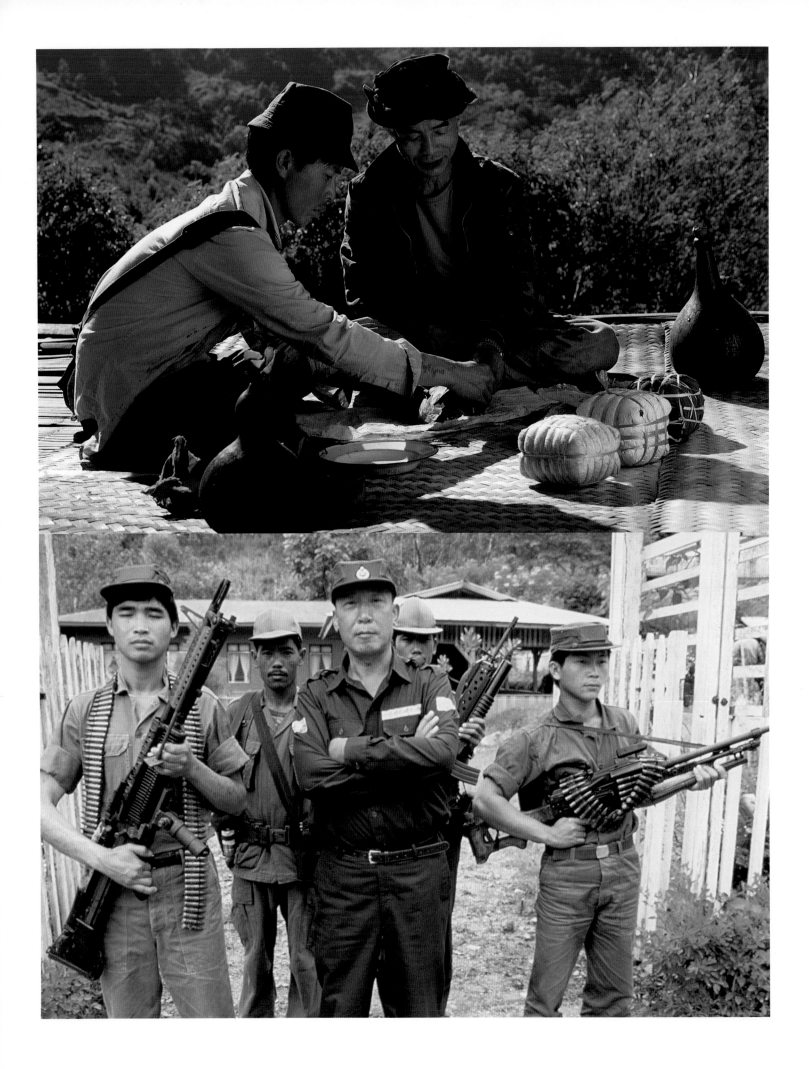

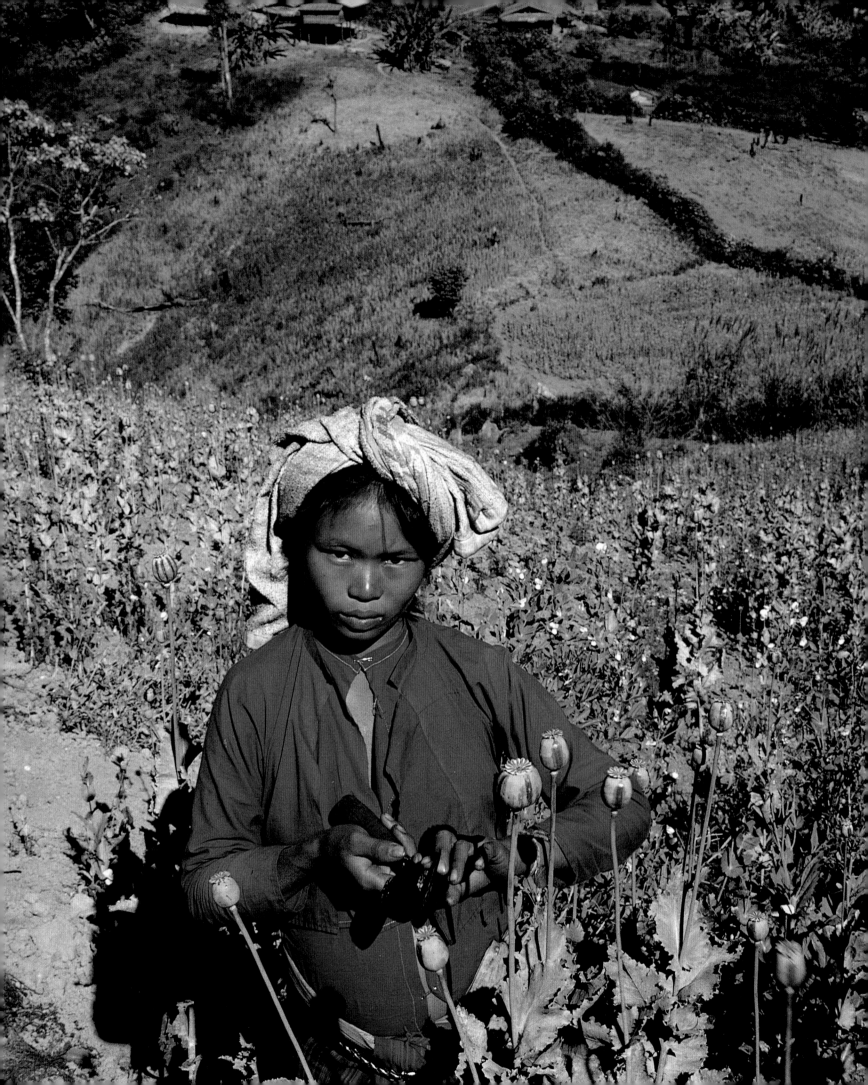

Burma is a hell for human rights. Military thugs, heroin corruption, and the complicity of China and Thailand have left the people of Burma too long isolated in a dark struggle.

Daniel P. Moynihan, 1992
United States senator

Previous spread, top left: Heroin traders in the Shan State of northeastern Burma. Since the SLORC took power, Burma's heroin production has doubled. The United States Drug Enforcement Administration reports that 60 percent of the world's heroin supply originates in Burma. Bottom left: The world's most notorious heroin drug lord and ruler of Burma's famed Golden Triangle, Khun Sa, flanked by his heavily armed guards. Right: A Shan girl has been hired to harvest opium from fields of poppies. When the poppy flower is cut, its black sap—raw opium—is gathered and then refined into pure-grade heroin.

Right: Under SLORC rule, Burma's deforestation rate has climbed to the third highest in the world. The SLORC has arranged lucrative logging deals with Thai companies in order to help finance its military arsenal and boost an economy on the verge of collapse. An area the size of El Salvador is being cleared each year. Environmental experts predict that Burma's natural forests will be completely denuded within ten years.

EPILOGUE

In the midst of the many dark developments shrouding Burma, Aung San Suu Kyi was awarded the Nobel Peace Prize in 1991. The Nobel Committee stated that she had become "one of the most extraordinary examples of civil courage in Asia in recent decades." Since she was still held incommunicado under house arrest, her older son Alexander, age eighteen accepted the prize in Oslo on his mother's behalf. In a moving speech he said, "Speaking as her son, I would add that I personally believe that by her own dedication and personal sacrifice she has come to be a worthy symbol through whom the plight of all the people of Burma may be recognized. No one must underestimate that plight. The plight of those in the countryside and towns, living in poverty and destitution, those in prison, battered and tortured; the plight of the young people, the hope of Burma, dying of malaria in the jungles to which they have fled; that of Buddhist monks, beaten and dishonored. Nor should we forget the many senior and highly respected leaders besides my mother who are all incarcerated. It is on their behalf that I thank you, from my heart, for this supreme honor. The Burmese people can today hold their heads a little higher in the knowledge that in this far distant land their suffering has been heard and heeded."

In May 1992, the SLORC allowed Dr. Michael Aris, Aung San Suu Kyi's British husband, and her two sons to visit her for the first time in almost three years. Evidence pointed to the likelihood of a motive: They hoped to entice her to leave the country and join her family. She had been given the option of "freedom" numerous times in exchange for permanent exile from her country, but had refused. Upon his return, Dr. Aris released a statement: "The offer was repeatedly made to release her if she went into exile. [She] never even discussed the matter because she says it is not negotiable....Since the day she began her endeavors, she resolved to stay and see it all through, come what may." Aris has since visited his wife several times.

In February 1993, six Nobel laureates and representatives of two Peace Prize-winning organizations (Amnesty International and the American Friends Service Committee) went on a well-publicized mission to Thailand and Burma (the SLORC refused them visas into Rangoon) to call for the release of their sister laureate, Aung San Suu Kyi. The participating Nobel laureates were Tibetan leader the fourteenth Dalai Lama (1989); former Costa Rican president Dr. Oscar Arias (1987); South African Archbishop Desmond Tutu (1984); human-rights activist Adolfo Perez Esquivel of Argentina (1980); and Mairead Maguire and Betty Williams, 1976 Peace Prize winners for their campaign for nonviolence in Northern Ireland. They met with Thai leaders, held press conferences, and visited Karen and Mon refugee camps along the Thai-Burma border. Laureates Elie Wiesel (1986) and Rigoberta Menchu Tum (1992) joined the group in Geneva, where they presented a joint statement to the United Nations

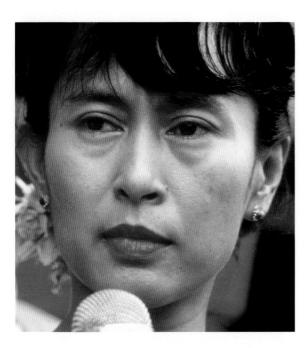

Above: Shortly before her house arrest in July 1989, Aung San Suu Kyi spoke out on behalf of all the ethnic minorities and the principles of democracy.

Opposite top: Aung San Suu Kyi's oldest son, Alexander, eighteen, received the Nobel Peace Prize award in Oslo, Norway, in December 1991, on his mother's behalf. His brother Kim, fourteen, stands beside him; Dr. Michael Aris, the Nobel laureate's husband, observes from the far right. Middle: In February 1993, six Nobel laureates and representatives of two Nobel Peace Prize-winning organizations traveled to Bangkok to publicly protest the continued detention of their sister laureate, Aung San Suu Kyi. (The SLORC refused them visas into Burma.) At a press conference in Bangkok, from left to right standing are Betty Williams, Mauread Maguire, Archbishop Desmond Tutu, Donna Anderton (American Friends Service Committee), Adolfo Perez Esquivel, and Ross Daniels (Amnesty International); seated (left to right) are Dr. Edward Broadbent (International Center for Human Rights and Democratic Development), Dr. Oscar Arias, and His Holiness the Dalai Lama. Bottom: Karen women dance to welcome the Nobel laureates to the refugee camp Huay Kra Lok in Thailand near the Burma border.

requesting that economic sanctions and an arms embargo be imposed against Burma. Mikhail Gorbachev, Mother Teresa, and Polish president Lech Walesa added written statements in support of the mission.

The SLORC's Major General Khin Nyunt said that the laureates were intruding into Burma's internal affairs and that they were meeting "with terrorists." As a result of the mission, laureates Archbishop Tutu and Betty Williams were granted a meeting with President Clinton on May 19, 1993. Clinton made the following statement: "I was moved by the stories of individual suffering I heard this afternoon and am deeply concerned by the tragic human-rights situation in Burma, as well as the continued detention of Aung San Suu Kyi. I strongly urge the Burmese government to release Aung San Suu Kyi and all political prisoners, to respect the results of the May 1990 elections, and to commit itself to genuine democratic reforms."

As of this writing, the SLORC has instituted an international campaign to counter its image as a violator of human rights. The U.S. government and the United Nations agree that some changes have occurred under the SLORC's current leader, Than Shwe, even though the SLORC's repressive tactics continue with the ongoing detention of Aung San Suu Kyi and the denial of the May 1990 election results.

In 1993-94, mass relocations of ethnic villages cleared the terrain for the SLORC's new business ventures and provided a readily available pool of slave labor. Political prisoners are still incarcerated, although some two thousand have been released. Refugees still live across the borders in Thailand, India, and Bangladesh. The illegitimate government may still be spending up to 40 percent of its gross national product on military hardware, which is used solely for the purpose of waging war against its own people. Concurrent with these atrocities, the SLORC has staged a number of "constitutional conventions" to give the impression that it has popular backing for a new constitution. However, provisions have been included in the constitution that solidify the army as the true power behind any future Burmese government. It has been well documented that the SLORC have also handpicked the "delegates" at the convention, and that those delegates who voice criticism of the regime are intimidated and even arrested. The purpose of the convention is clearly aimed at legitimizing a permanent military dictatorship.

In December 1993, the SLORC issued a statement announcing that Aung San Suu Kyi will under no circumstances be released. Dr. Sein Win, prime minister of the National Coalition of the Union of Burma (the interim parallel government), spent the fall of 1993 working at the United Nations in a so-far unsuccessful effort to remove the SLORC seat from the General Assembly. In cooperation with the Thai and Chinese governments, the SLORC have successfully pressured most ethnic

Aung San Suu Kyi, sister in the struggle for peace. . . No one enemy of justice can silence your voice for freedom, which is your father's voice and the voice of expression of your people. No prison can halt your love and courage which was forged with sorrow and hope. Your resistance is a source of inspiration for a new beginning.

Rigoberta Menchu Tum
Guatemalan human rights activist
Nobel Peace laureate, 1992

Opposite, clockwise from top right: His Holiness the Dalai Lama of Tibet spoke on behalf of Aung San Suu Kyi at the mission's press conference in Bangkok, February 1993; Aung San Suu Kyi wrote numerous essays in her Rangoon home during Burma's upheaval in the final months of 1988; while in detention, Aung San Suu Kyi was visited by her two sons, Alexander (left) and Kim (right) in May 1993; Former Costa Rican president and 1987 Nobel laureate Dr. Oscar Arias spoke about Burma before the United Nations Human Rights Commission in Geneva on behalf of all the laureates who participated in the mission to Bangkok; Elie Wiesel (Nobel laureate 1986) also attended the Geneva session in support of Burma.

minorities to sign a "truce" with the Rangoon government. First to sign were the Kachins, who felt they could not survive unless they cooperated with the terms of the SLORC agreement. Soon thereafter, the Karens, Mons, and other minority groups began negotiating with the military junta in Rangoon in an effort to maintain their autonomy. Despite these coerced cease-fire agreements, the SLORC steadfastly continues to detain Aung San Suu Kyi and ignore the results of the May 1990 elections.

Aung San Suu Kyi is an extraordinary woman. Her courage and will inspire others around the world who suffer under repressive regimes. Offered exile if she ends her struggle against the dictatorial Myanmar regime, she has remained steadfast to her principles and her cause. She has refused all forms of support from either her family or her captors so as not to compromise herself or her people.

Despite the international community's demands, the Burmese government continues to deny Aung San Suu Kyi her fundamental human rights. When a group of Nobel laureates undertook a mission to Burma in February 1993, we hoped to increase the pressure on the Myanmar regime to free Aung San Suu Kyi and other political prisoners, restore democracy, and build a basis for a progressive human-rights program. Although we were denied entry into that country, our hopes as well as our goals did not dissipate. The personal testimonies of men and women who had to flee the terror that engulfed them in Burma, the degradation of women and children who were raped and beaten by persons of the ruling military regime, all served to inspire us to search for a way to end their hopeless suffering. It is important to increase the awareness of other nations that these atrocities cannot and must not continue.

Aung San Suu Kyi serves as a reminder to us all that the commitment to nonviolence against aggressive violence, although deflected, cannot be ignored. I know the courage of this incredible woman will bring forth freedom and democracy for the people of Burma. She will show the world the strength and power of nonviolent resistance.

Dr. Oscar Arias
Former president of Costa Rica
Nobel Peace laureate, 1987

TOWARDS A
TRUE REFUGE

by Aung San Suu Kyi

The following excerpt from the essay "Towards a True Refuge" by Aung San Suu Kyi was delivered by her husband Dr. Michael Aris in May 1993 at Oxford University. It is the most recent piece of writing by Aung San Suu Kyi to have been allowed out of Rangoon, and a product of her solitary house arrest. We include here the concluding portion of the essay in its entirety. This statement is a testament to her dignity and wisdom, which have not been dimmed by her long detention.

It is perfectly natural that all people should wish for a secure refuge. It is unfortunate that in spite of strong evidence to the contrary, so many still act as though security would be guaranteed if they fortified themselves with an abundance of material possessions. The greatest threats to global security today come not from the economic deficiencies of the poorest nations but from religious, racial (or tribal), and political dissensions raging in those regions where principles and practices which could reconcile the diverse instincts and aspirations of mankind have been ignored, repressed, or distorted. Man-made disasters are made by dominant individuals and cliques which refuse to move beyond the autistic confines of partisan interest. An eminent development economist has observed that the best defense against famine is an accountable government. It makes little political or economic sense to give aid without trying to address the circumstances that render aid ineffectual. No amount of material goods and technological know-how will compensate for human irresponsibility and viciousness.

Developed and developing nations alike suffer as a result of policies removed from a framework of values which uphold minimum standards of justice and tolerance. The rapidity with which the old Soviet Union splintered into new states, many of them stamped with a fierce racial assertiveness, illustrates that decades of authoritarian rule may have achieved uniformity and obedience but could not achieve long-term harmony or stability. Nor did the material benefits enjoyed under the relatively successful post-totalitarian state of Yugoslavia succeed in dissipating the psychological impress of brooding historical experiences which have now led to some of the worst religious and ethnic violence the Balkans has ever witnessed. Peace, stability, and unity cannot be bought or coerced; they have to be nurtured by prompting a sensitivity to human needs and respect for the rights and opinions of others. Diversity and dissent need not inhibit the emergence of strong, stable societies, but inflexibility, narrowness, and unadulterated materialism can prevent healthy growth. And when attitudes have been allowed to harden to the point that otherness becomes a sufficient reason for nullifying a person's claim to be treated as a fellow human being, the trappings of modern civilization crumble with frightening speed.

In the most troubled areas of the world, reserves of tolerance and compassion disappear, security becomes nonexistent, and creature comforts are reduced to a minimum—but stockpiles of weapons abound. As a system of values this is totally mad. By the time it is accepted that the only way out of an impasse of hate, bloodshed, and social and economic chaos created by men is for those men to get together to find a peaceful solution through dialogue and compromise, it is usually no longer easy to restore sanity. Those who have been conditioned by systems which make a mockery of the law by legalizing injustices and which attack the very foundations of harmony by perpetuating social, political, and economic

The life of nations, many times, traverses surprising and unforeseen roads, depending in great measure on the attitudes assumed by their leaders and the stages on which their historical events unfold.

Burma, the ex-Burma, is today a nation subjected to an iron military dictatorship that considers itself "masters of life and death" for the entire nation and is responsible for serious human-rights violations, both personal and national. This military dictatorship, like many, doesn't sustain itself alone but has accomplices, allies, and other countries that support and receive benefits at the cost of repression, the hunger of the nation.

Together with other Nobel Peace Prize winners the Dalai Lama, Archbishop Desmond Tutu, Mairead Maguire, and Dr. Oscar Arias, I am giving notice of an international action, the object of which is to make a call to the international conscience and denounce before the United Nations the grave situation and suffering of the Burmese people under a military regime. And fundamentally to rescue the liberty and rights of a woman who, with dignity and fortitude, has transformed herself into a symbol of resistance, striving for liberty and democracy for her people. She is Aung San Suu Kyi, who was detained more than three years ago by order of the dictators' State Council for the Restoration of Law and Order, a government that, in fact, respects no law and has caused the displacement of democratic institutions.

It is suitable to note that in the face

of liberty every citizen respects just law and has not only the right but the moral obligation of his conscience to resist and disobey unjust laws that attack the life and rights of a nation.

Aung San Suu Kyi reaffirmed the bond with her nation by resisting the oppressive violence of the military dictatorship with dignity and a moral and spiritual conscience through non-violence. Her actions have transcended Burmese borders and generated international solidarity.

It is necessary to support the Burmese resistance with all of our efforts. Aung San Suu Kyi is, in her fragile appearance, the force born of truth and justice, the road by which a base for peace can be built.

Adolfo Perez Esquivel
Argentine human-rights activist
Nobel Peace laureate, 1980

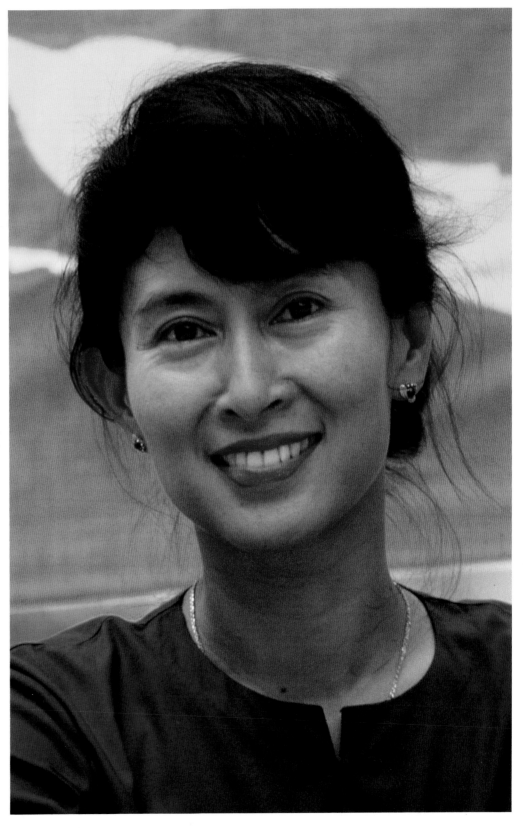

Aung San Suu Kyi's courage in working for human rights and democracy in Burma, and her own personal sacrifice and suffering to reach these aims, have touched the conscience of many, and reminded us that one person, whose motives are pure and based on love and service, can make a real difference. Her enforced "silence" under house arrest in her Rangoon home is clearly heard in every corner of our global village, and challenges each of us to do what we can through the means of nonviolence, and thus make a real difference in Burma and in our world.

Mairead Maguire
Northern Irish peace activist
Nobel Peace laureate, 1976

imbalances cannot adjust quickly—if at all—to the concept of a fair settlement which places general well-being and justice above partisan advantage.

During the cold war the inequities of ruthless governments and armed groups were condoned for ideological reasons. The results have been far from happy. Although there is greater emphasis on justice and human rights today, there are still ardent advocates in favor of giving priority to political and economic expediency—increasingly the latter. It is the old argument: Achieve economic success and all else will follow. But even long-affluent societies are plagued by formidable social ills which have provoked deep anxieties about the future. And newly rich nations appear to be spending a significant portion of their wealth on arms and armies. Clearly there is no inherent link between greater prosperity and greater security and peace—or even the expectation of greater peace. Both prosperity and peace are necessary for the happiness of mankind, the one to alleviate suffering, the other to promote tranquillity. Only policies which place equal importance on both will make a truly richer world, one in which men can enjoy chantha [prosperity and happiness] of the body and of the mind. The drive for economic progress needs to be tempered by an awareness of the dangers of greed and selfishness which so easily lead to narrowness and inhumanity. If peoples and nations cultivate a generous spirit that welcomes the happiness of others as an enhancement of the happiness of the self, many seemingly insoluble problems would prove less intractable.

Those who have worked with refugees are in the best position to know that when people have been stripped of all their material supports there only remain to sustain them the values of their cultural and spiritual inheritance. A tradition of sharing instilled by age-old beliefs in the joy of giving and the sanctity of compassion will move a homeless destitute to press a portion of his meager rations on strangers with all the grace and delight of one who has ample riches to dispense. On the other hand, predatory traits honed by a long-established habit of yielding to "every urge of nature which made self-serving the essence of human life" will lead men to plunder fellow sufferers of their last pathetic possessions. And of course the great majority of the world's refugees are seeking sanctuary from situations rendered untenable by a dearth of humanity and wisdom.

The dream of a society ruled by loving kindness, reason, and justice is a dream as old as civilized man. Does it have to be an impossible dream? Karl Popper, explaining his abiding optimism in so troubled a world as ours, said that the darkness had always been there but the light was new. Because it is new it has to be tended with care and diligence. It is true that even the smallest light cannot be extinguished by all the darkness in the world because darkness is wholly negative. It is merely an absence of light. But a small light cannot dispel acres of encircling gloom. It needs to grow stronger, to shed its brightness further and further. And people need to accustom their eyes to the light to see it as a benediction rather than a pain, to learn to love it. We are so much in need of a brighter world which will offer adequate refuge to all its inhabitants.

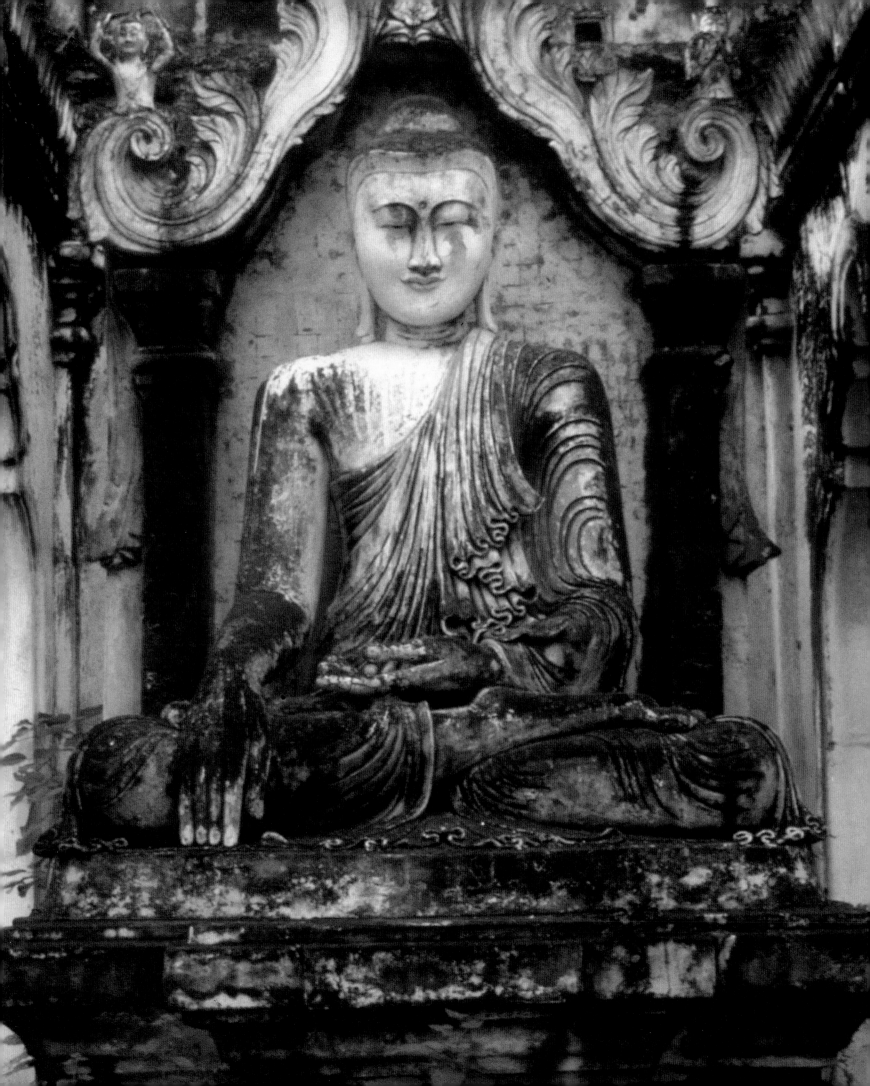

ACKNOWLEDGMENTS

It is with deep gratitude that we acknowledge the many people who were part of this inspiring project.

First and foremost, we are indebted to the numerous photographers who contributed over three thousand images to this project, some of whom took great risks to document the crisis and smuggle material out of Burma. They not only provided essential material for bringing this book to life, but many extended themselves well beyond what was required.

We wish to express our gratitude to Michael E. Hoffman of the Aperture Foundation for believing in this project, and to Andrew Wilkes, our editor from Aperture, who patiently and skillfully transformed the book through its many complex phases of development. Roger Gorman of Reiner Design expertly crafted the design of the book, and Jessica Brackman of FPG International generously contributed her skills towards photo research, providing timely advice whenever it was needed.

We would like to thank the Nobel Peace laureates Oscar Arias, Adolfo Perez Esquivel, Mairead Maguire, Rigoberta Menchu Tum, Archbishop Desmond Tutu, and Betty Williams for their written contributions to the book, along with His Holiness the Dalai Lama for his compassionate foreword. We are also indebted to Prime Minister Dr. Sein Win for writing the preface. Thanks to Burma experts Dr. David I. Steinberg of Georgetown University and Dr. John Badgley of Cornell University for reading the manuscript and offering many helpful suggestions, which proved essential to the completion of the text.

Valuable contributions were made by Michele Bohana of the Institute for Asian Democracy; Margery Farrar, special assistant to Congressman Tom Lantos; Patricia Herbert of the British Library, Southeast Asian Collections; Lodi Gyari and John Ackerly of the International Campaign for Tibet; Jigme Yugay, John Isom, and Bonnie McCalla of Bay Area Friends of Tibet; Danielle Valiquette of the Center for Human Rights and Democratic Development; Leon Desclozeux of Zeaux Productions, Paris; Ethan Casey, editor at the *Bangkok Post*; Maria Vazquez of the Vicente Menchu Foundation; Sarah Jane Freyman of the Stepping Stone Literary Agency; and Ray Young of PhotoGenesis.

We appreciate additional key support provided by Victor Alas, Lee Bassett, Chris Coughlin, Hatem El-Sayed, Jeanne Hallacy, Sally Knight, Kim Komenich, Shirlee Quick, Bilal M. Raschid, and Jerry Rosser.

We gratefully acknowledge the Threshold Foundation of San Francisco for their generous grant, without which this book would not have been possible. In particular, we thank Threshold members Dan Moore and Sandra Mabritto for so enthusiastically believing in the project from the very beginning, and for passionately caring about the crisis in Burma. Mickey Lemle, Marguerite Craig, and Martha Abelson have also provided valuable assistance through the Threshold Foundation. Equally, we extend our sincere thanks to Hamilton F. Kean, whose timely gift gave us the means and confidence to proceed with the book in the early stages.

Additional funding was provided by the Buddhist Churches of America, the Ralph E. Ogden Foundation, and the Glad Foundation; substantial donations were also given by Ellen S. Kean and Larry Shank. We thank collectively the group of additional individuals who supported the Burma Project USA at various stages along the way.

Finally, we extend our heartfelt appreciation to all those who have not been mentioned, not only for ourselves, but for the millions of oppressed people in Burma who we hope will benefit the most from this collaborative effort.

PHOTO CREDITS:

Cover: Steve Lehman/SABA. 1. Oriental and India Office Collections, British Library; 2-3. Josef Beck; 4. Alain Evrard/Impact Photos; 6. Mitch Epstein; 8. Masao Endoh; 10. Henri Cartier-Bresson/Magnum; 12. Map by John Isom; 14. Courtesy of Bilal M. Raschid; 15. J.G. Scott/Oriental and India Office Collections, British Library; 17. Watts & Skeen/Oriental and India Office Collections, British Library; 19. Henri Cartier-Bresson/Magnum; 20. Piers Cavendish/Impact Photos; 21. Wilhelm Klein; 22-23. Pam Taylor; 24. Steve Gardner; 25. Colin Jones/Impact Photos; 26-27. Robert Semeniuk; 28. Robert Semeniuk; 29. above, right, Robert Apte; below, right, Robert Semeniuk; 30-31. Piers Cavendish/Impact Photos; 32-33. Sandro Tucci/Black Star; 34. top row, left to right; Steve Gardner, Brian Linkletter, Wilhelm Klein; middle row, left to right; Bruce Haley/Zuma Images, Dominic Faulder/ Bureau Bangkok, Steve Gardner; bottom row, left to right; Piers Cavendish/ Impact Photos, Steve Gardner, Steve Gardner; 35. Above, Dominic Faulder/ Bureau Bangkok; below, Jeanne Hallacy; 36. Alain Evrard/Impact Photos; 37. Tom Lubin; 38. Tom Lubin; 39. Alain Evrard/Impact Photos; 40-41. Alain Evrard/ Impact Photos; 43. Above & below; Alain Evrard/Impact Photos; 44. Steve Lehman/SABA; 45. Above, left, anonymous; above, right; Steve Lehman/ SABA; bottom, Steve Lehman/SABA; 46. Steve Lehman/SABA; 47. Steve Lehman/ SABA; 48-49. Steve Lehman/SABA; 50. Dominique Aubert/Sygma; 51. Dominic Faulder/Bureau Bangkok; 52. Burma Project USA; 53. Above, Sandro Tucci/ Black Star; below, left and right; Burma Project USA; 54-55. Dominic Faulder/ Bureau Bangkok; 56. top row, Dominic Faulder/Bureau Bangkok; below, left, *Working People's Daily*; below, right, Alan Clements/Burma Project USA; 57. B.U.R.M.A.; 58. Dominic Faulder/ Bureau Bangkok; 59. Steve Lehman/ SABA; 60. Geoffrey Klaverkamp/ Asiaweek; 61. Above & below, Geoffrey Klaverkamp/Asiaweek; 62. Steve Gardner; 63. Bruce Haley/Zuma Images; 64-65. Alan Clements/Sygma; 66. left, B.U.R.M.A.; right, Masao Endoh; 67. Bruce Haley/Zuma Images; 68. Brian Linkletter/Sygma; 69. Alan Clements/Burma Project USA; 70. Reuters/ Bettman; 71. Above, Mimi Forsyth; bottom, Edward Peters/Impact Visuals; 72-73. Dominic Faulder/Bureau Bangkok; 74-75. AFP PHOTO; 76. Peter Conrad; 77. Frank Barbieri; 78. Masao Endoh; 79. J.B. Avril; 80-81. Bruce Haley/Zuma Images; 82. Suzanne Keating; 83. Above, Piers Cavendish/ Impact Photos; below, Steve Gardner; 84. Steve Gardner; 85. J.B. Avril; 86-87. Robert Semeniuk; 88-89. Bruce Haley/Zuma Images; 90-91. Steve Gardner; 92. left, Masao Endoh; right, Bruce Haley/Zuma Images; 93. Piers Cavendish/Impact Photos; 94-95. Piers Cavendish/Impact Photos; 96. Above, Bruce Haley/Zuma Images; below, Piers Cavendish/Impact Photos; 97. Piers Cavendish/Impact Photos; 98-99. Fuminori Sato/Impact Visuals; 100. Dominic Faulder/Bureau Bangkok; 101. Above, Kyin Ho, M.D.; middle, Wiruch Thongchew/Bureau Bangkok; below, SAIN/ICHRDD/Jack Noble; 103. clockwise from above right; Dominic Faulder/Bureau Bangkok; Dominic Faulder/Bureau Bankok; Burma Project USA; Morvan/Gamma Liaison, Morvan/Gamma Liaison; 104. Sandro Tucci/Black Star; 107. Jann Subiaco.